BANKSY
IN NEW YORK

by **RAY MOCK**

The purpose of this book is to document street art and graffiti in New York. Carnage NYC is in no way affiliated with the artist known as Banksy. Carnage NYC has made every effort to ensure the accuracy of the information contained in this book and does not accept responsibility for any errors or omissions.

The copyright for all images supplied to the publisher by contributors remains with the originators.

Designed and written by Ray Mock.

Printed in China.

ISBN: 978-0-9906437-1-5

© Carnage NYC

www.carnagenyc.com
Instagram: @carnagenyc
carnagenyc@gmail.com

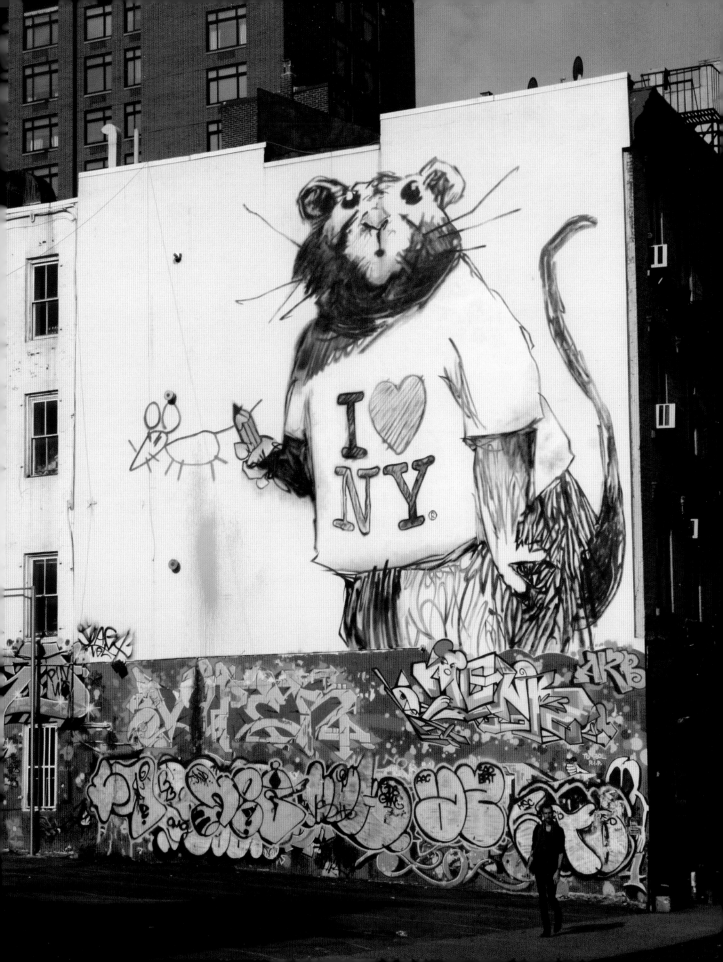

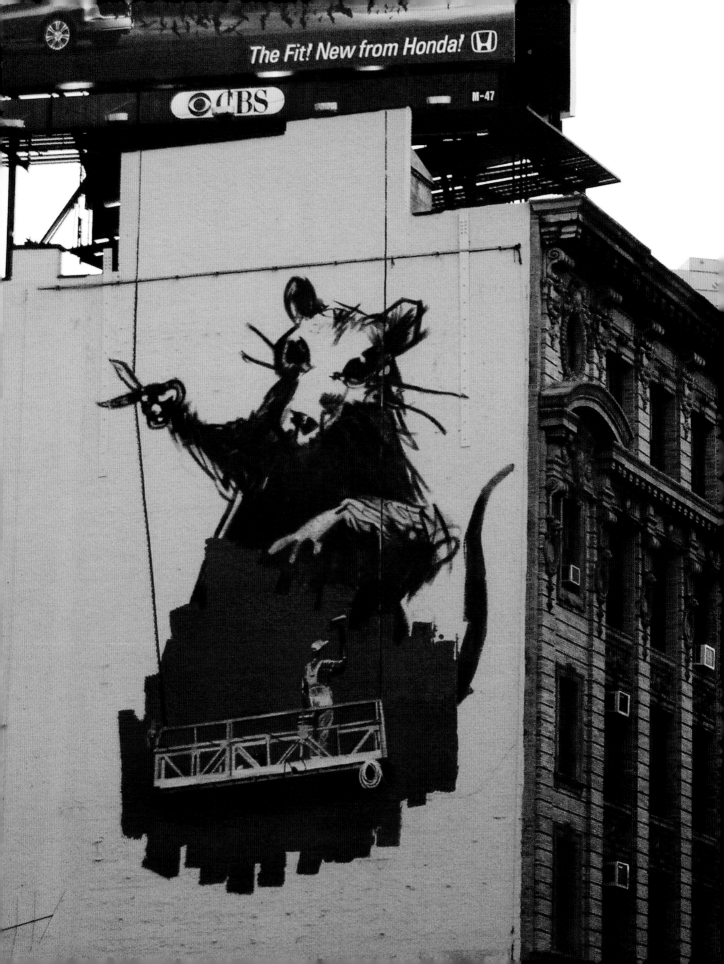

PREFACE

By Steven P. Harrington and Jaime Rojo

New York has a vibrant and badass street art and graffiti scene, and has had one for years. Standing somewhere between vandalism and artistic free speech, its origins in aerosol writing half a century ago have expanded and have been infused with every manner of art-making possible. Illegal by nature, street art and graffiti are organic and always evolving, gritty and polished, fresh and weathered, underwhelming and sublime: at any moment it is a multi-headed hydra that taunts its critics and cavorts with its fans. This ongoing conversation appears wherever it likes: on abandoned buildings, in empty lots or dimly-lit tunnels, under bridges, along railroad tracks, on chain link fences or electrical boxes, in bus shelters and the most random places imaginable. For those who participate in or follow it, street art and graffiti have a history of development that is claimed, qualified, owned, fought over and prophesized.

The international street art scene that has grown and flourished during the last 15 years is unprecedented from a variety of perspectives; principal among them is that the ease of sharing its explosion via digital technology has fostered a de facto first global grassroots people's art movement, with nary a gatekeeper and open to almost all. Magnificently chaotic and unmanageable with an ocean of participants including artists, fans, photographers, writers, academics, critics, historians, anthropologists, ethnographers, collectors, galleries, museums, advertisers and designers all eager to capture and characterize its essence, the contemporary street art scene now spans hundreds of cities and towns and has even made appearances in rural areas.

Cast upon the digital ocean of our new post-Gutenberg era of deliberately and discursively relaying news, images, and opinion digitally from a magnitude of contributors in ways never before possible, it is notable that only a certain handful of street artists have risen to international notoriety to become household names. Perched atop this global pile for the last decade or so has been the Bristol, England native who goes by the name of Banksy.

Famously anonymous, and a reliably wisecracking saccharine, salty, and sarcastic observer of our hypocrisies

and foibles, Banksy has used his aerosol stencils on walls to lampoon and skewer the sacred and the banal. With an eye for good placement, he has been an admired comedian, critic, quipster, and philosopher. His insightful observations are rarely withering and often delivered with a spoonful of sugar. While he is positioned as a critic of western culture and of our rather soulless consumption-based habits enabled by the seductively cynical world of advertising, he is also known to be rather adept at employing his own cunning persuasion as well.

Once a simple one-color stencil artist on the street and now a coveted global artist to collect, Banksy's own repertoire has broadened to include elements of all manner of fine art, pop satire, culture jamming, outsider art, installation, and performance – in short, some of the myriad styles now included in the canon of street art. In the media and advertising soup in which we all are swimming, whether by his own hand or that of assistants, the Banksy name has evolved into a brand and every move he makes can be interpreted as part of a campaign at this point.

And so it was during the month of October, 2013 that the enigma wrapped in a riddle chose the media capital New York to launch "Better Out Than In," a self-described and self-directed artist "residency" that took place in the public sphere and virtual ones as well, all helpfully guided by an official @banksyny Instagram account and website. While few can say with surety if Banksy the artist did any of the various installations in this residency, we do know that a feeding frenzy erupted as each day progressed and that the thousands of discussions it engendered reignited the brand and captured many new fans.

In the midst of a U.S. government shutdown and a severely schizophrenic economy that has squeezed many to a breaking point, suddenly we had a secular Easter Bunny in Gotham who came in the night and left presents for us to hunt, and clues as well. Now the GPS and geo-locating on our smart phones made sense and our own connection to and knowledge of the city became enhanced. A complete surprise, with a rather abrupt announcement rippling through social channels, gave way to a free interactive game for everyone to play in the city, and you might even talk to another New Yorker in the process.

Brand new Banksy pieces got shot by fanboys, buffed by graffiti writers,

and chain-sawed by speculators. Closely surveilled by Instagram followers and breathlessly reported on Twitter, with more detailed missives emanating from the home-base of Banksy's website, every utterance was pounced upon by fans, including an ardent team of photographers, art-bloggers, grand-standers and entrepreneurs.

Competitive instincts were fueled by an adrenaline rush of mystery fanned by the wings of a waspy storm of crowd-sourcing and social-media-monitoring, energized by the crisp air of autumn in New York.

Like an electronic Pied Piper, this entertaining humorist issued a high-alert signal into the air, sending fans and others scrambling into parts of New York they had never heard of, let alone visited. The city prides itself on its liberal values, but it is still very segregated by race, income, class, and culture - but somehow many didn't really know that until Banksy compelled them to venture into another neighborhood via train, bus, car, bicycle or on foot. With his deliberate and at times flummoxing program, the visiting piper led public art seekers on a herky-jerky wagon ride, to the thrill and chagrin of many.

In our article entitled "Banksy's Final Trick," which appeared on the Huffington Post a day after the end of his run, we described how Banksy had somehow transformed nearly everything we saw in the street:

No longer asking, "Who is Banksy," many strolling New Yorkers this October were only half-kidding when they would point to nearly any scene or object on the street and ask each other, "Is that a Banksy?" And truly, what better global brand can claim to have triggered this thought in someone's mind by not actually doing anything yourself?

After all, the newest Banksy could be just about anything. His month-long street show included sculpture, live performance, live ants, puppetry, canned music, live music, screaming stuffed animals, costumed actors, complex displays, one-layer stencils, a pissing dog, a patient priest and the Grim Reaper driving in a bumper car to the sounds of Blue Oyster Cult. All of it was tweeted, texted, posted, printed, videoed, and otherwise relayed to clans and groupies across devices, platforms, screens and ecosystems in real time. Some people even had the new works tattooed, which shouldn't be that surprising since this is a vandal whose deeds actually raise the value of property.

In our own experience as street art observers during this one-

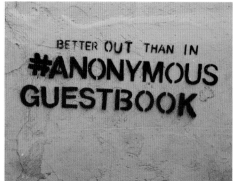

month campaign, we found ourselves overcome with excitement throughout the month but it was always tempered by curiosity about the behaviors of the public as we collectively discovered each installation. As news grew and participation increased, increasingly wide circles outside the core street art community became fluent in the details of the events around the city and the large media organizations, arts professionals, law enforcement, and politicians each weighed in on Banksy with their perspectives. Each day saw a different aspect of the circus, with the master behind the puppet show carefully calibrating messages with sardonic wit and insight.

In the midst of a surge in street art festivals around the world and many large, elaborate permissioned/ commissioned murals in public space, it was astounding to see the excitement generated by ostensibly illegal street art. The roots of the renegade rule-breaker mentality has always been endemic to a segment of American youth culture and here the appeal was clearly on display again with a daily spectacle and a collective cheer for the clever mystery man for getting away with something possibly criminal.

At times the hype bordered on hysteria – crowded sidewalks for hours, a multitude of cameras jockeying for shots, insta-guards

pacing quizzically, ruffians removing artworks, the star vandal being vandalized by a lesser known vandal who in turn is confronted, entrepreneurs charging admission to unshroud the work, experts and charlatans "educating" the assembled unwashed, and the mouth-agape incredulity of a mob watching as a large "B-A-N-K-S-Y" balloon is dragged through the air and laboriously stuffed into the back of a police van by uniformed officers.

It was at that precise juncture when our own involvement crossed from observers to unwitting participants in the Banksy circus. Jaime was one of the many clustered photographers

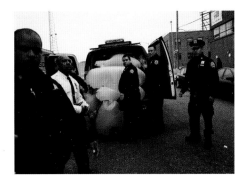

documenting the balloons being corralled when swiftly an officer approached him and grabbed his arm; within moments he was handcuffed and stuffed into the back of a squad car like one of the balloons. After two more minutes the chief lieutenant poked his head through the open window in the police car to look at Rojo and told

the officer "You have the wrong man." Yet it took three more hours until Jaime received an apology and was released from the precinct in a case of mistaken identity, but not before spending quality time in the cell with the two guys arrested for taking down the balloons.

Banksy In New York follows the daily events as they unfolded with the sort of dry-eyed astuteness that only a veteran observer of street art and graffiti in New York can offer. A recognized and trusted expert who has documented modern graffiti through his photography and high-quality publications for many years, Ray Mock reveals more about Banksy's characteristic stagecraft and sleights of hand than the surface messages of the art and the ensuing zoo. With some detective skill and his healthy distrust of marketing flimflam, Ray's insights and questions provide a guide through each day of the month. He also reveals some surprising facts that only a local graffiti expert would know about the installations, their environment and public perceptions surrounding them.

With "Better Out Than In" the swelling and fast-talking crowd of fans and sworn enemies of street art was undeniable and rather inescapable; the hunt to discover became entwined with the desire to see a new Banksy piece before it was defaced or absconded with. In

a city where folks gladly give you unsolicited opinions, smartphones were running hot with information, photos, praise and catty observations for hours across social networks. Whatever high-minded or self-serving goals Banksy may have had, he could not have anticipated exactly the nature of the results nor how the entire scene took on a life of its own. The most noteworthy and possibly most obvious outcome is that with his "residency" Banksy managed to re-engage many New Yorkers with their own city, with their observation skills, their appreciation for artistic expression, and most surprisingly perhaps, with one another. Star power aside, that level of engagement in the public sphere would simply be called a success.

Steven P. Harrington and Jaime Rojo are Co-Founders of BrooklynStreetArt.com and write a weekly column on the global street art scene for The Huffington Post.

BANKSY
IN
NEW
YORK

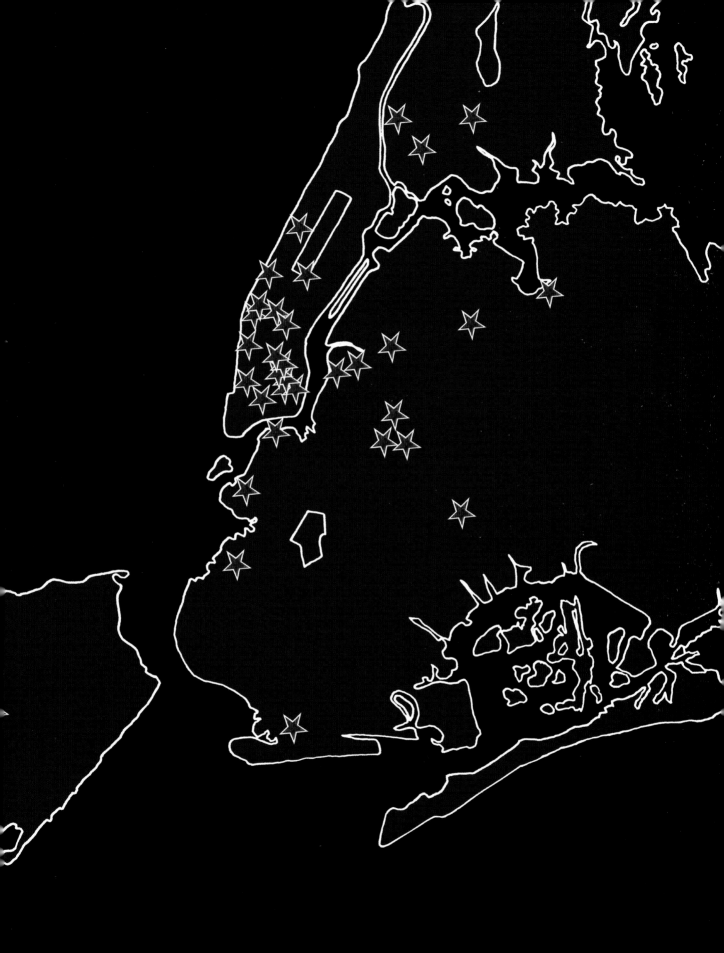

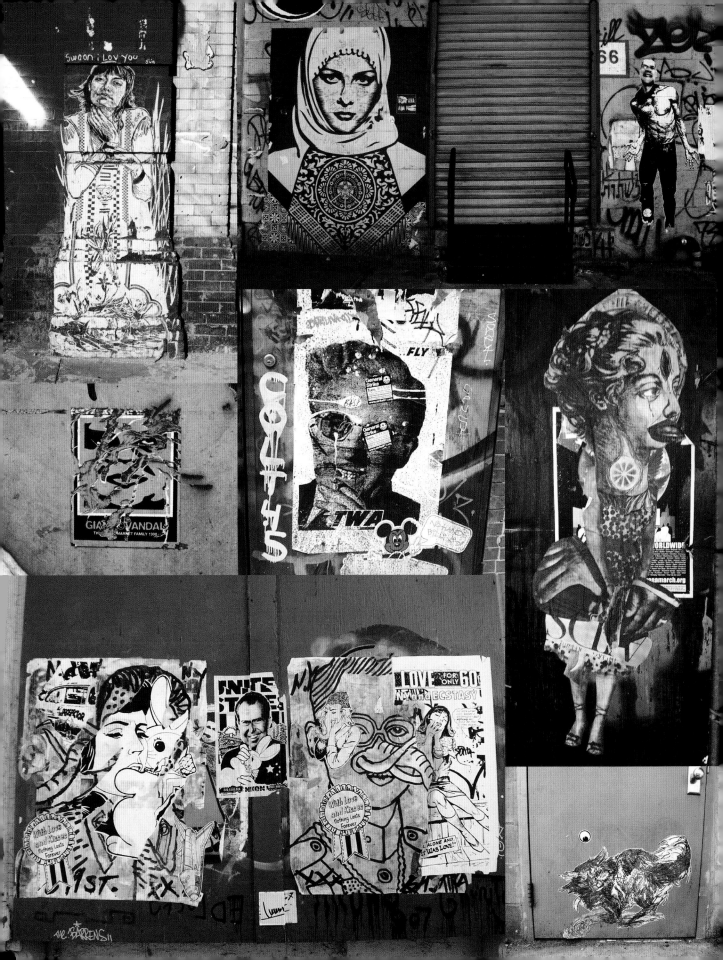

INTRODUCTION

Word got around quickly on October 1, 2013. One of my photographer friends texted me. A photo popped up on Instagram, followed by a few more. Soon there was also a dedicated website, and the suspicion grew into certainty: Banksy was back in New York City and had left what was the first of surely several pieces, in Chinatown, close to a previous spot of his. I was still at work in my Midtown office, so I grudgingly accepted that I would have to wait until later to find the piece and shoot it.

And anyway, I was over Banksy. Sure, he was one of the first street artists to whom I paid any attention, along with Shepard Fairey, Swoon, Faile and Bast, when the term street art still connoted something secret, renegade and anti-authoritarian. Back then, there were no street art apps or official maps, only random encounters with art and photos exchanged via online forums and Flickr. Collectors had already driven up the prices of prints and original artwork by some of these artists, but most people had only a fleeting idea of what street art was, leaving it to me to discover it on my own, by tirelessly walking the streets of the city.

It was as much an excuse to get out of the house and walk down random blocks in neighborhoods across the five boroughs of New York to which I'd

Clockwise from top left: Swoon, Obey,
WK Interact and Stikman, Judith Supine,
Elbow-Toe, Faile, Bast and again Obey.
Center: Bast

never been before as to take photos of the art, or however one wanted to define the often scrappy and sometimes masterly wheatpastes and stencils I found. Every day there was more to learn and more to see. Photographing street art quickly became an all-consuming obsession.

So maybe I became a little bit of a Banksy fan back then. I struck out at all of his print releases, but traveled multiple times to London and Bristol to hunt down every surviving piece of his that I could find, armed with reams of Google map print-outs (again, no apps yet). I might have been a wee bit psyched when he returned to New York to open his pet shop installation, the Village Pet Shop and Charcoal Grille, and when the company that was charged with painting billboard-size Banksy murals on his behalf was kind enough to tip me off to them beforehand. And, I admit, when I went to New Orleans post-Katrina, ostensibly to shoot the work of Bookman, aka the Reader, I also made sure to track down all of Banksy's pieces there. And in San Francisco. And Boston. And Los Angeles. And again in New York.

So yeah, I guess you could say I liked his work. It spoke to me, like a good cup of coffee, or an old acquaintance who comes back to town every few years and hasn't really changed all that much, other than becoming a world-wide pop art phenomenon.

By October of 2013 though, I was feeling fairly ambivalent about street art in general and Banksy in particular. There were many talented (and many more horribly untalented) street artists and muralists travelling on the global urban art circuit, painting the same walls in glorious colors the world over, usually with the blessing of local authorities and property owners. Countless books on the subject had been published, blogs and independent photographers abounded and street art exhibits filled major museums. It was as if one of your favorite bands had produced a hit record and was suddenly playing big arenas. You had to be happy for them, but you couldn't help but miss the days when you could see them for $10 in a small club surrounded by drunk, stinking punks rather than drunk frat boys. So you dig deeper and look elsewhere for your next favorite band.

I had mostly been shooting graffiti in recent years, preferably grimy tagged up doors, man-size fill-ins, freight trains and illegal pieces in abandoned buildings or along railroad tracks. I had also started to make my own photo zines, out of frustration with the glut of photos online and the short public attention span for digital documentation. I was fortunate to collaborate with some of the most relevant graffiti writers in the U.S. on creative projects.

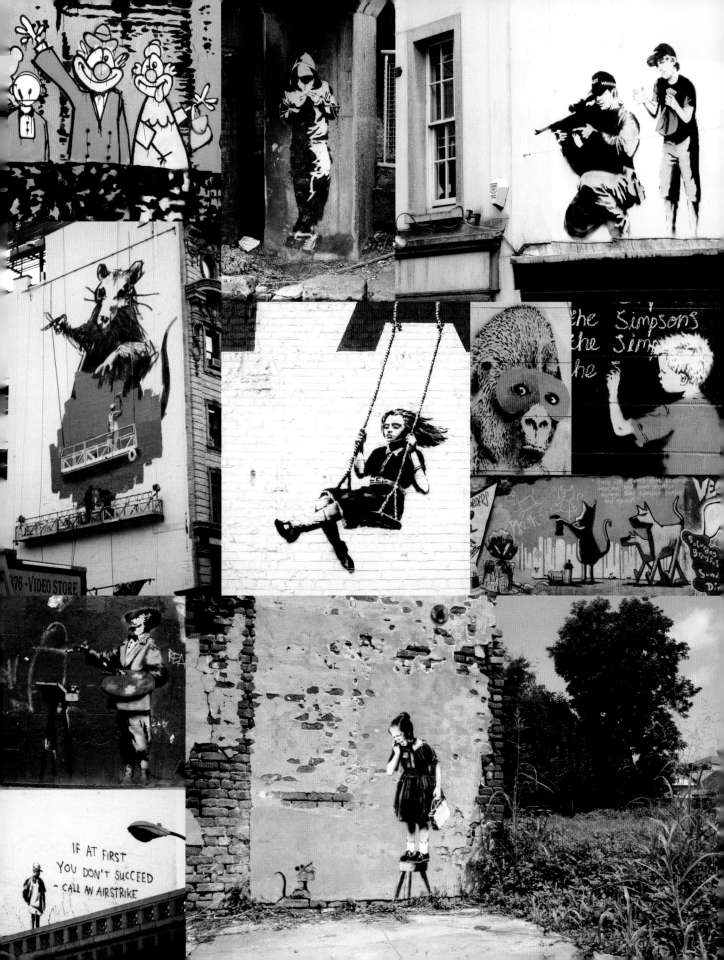

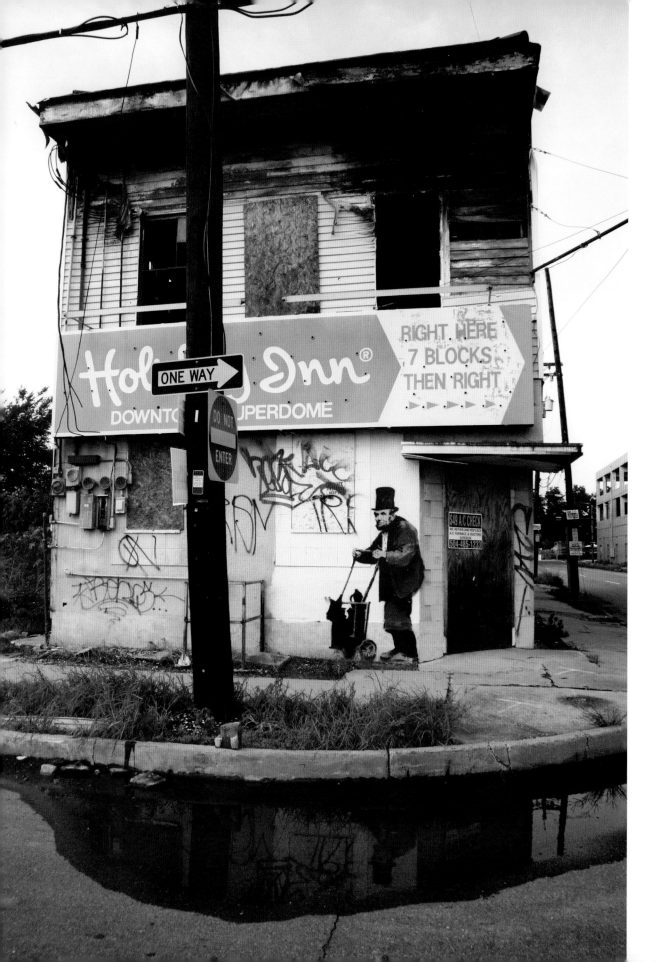

As I learned more about graffiti culture and its value system, I came to appreciate the extreme lengths to which writers go in order to achieve visibility, either in quantity or quality, and sometimes in both.

The irony was, perhaps, that graffiti tends to be fairly conservative about style and fundamentalist in some of its values (not to mention the occasional, inexcusable homophobia and misogynism that comes with a mostly young, mostly male group of practitioners). Street art tends to be more open-minded, though the line I am drawing between the two is fluid, and real innovators aren't afraid to work on both sides of the fence. But more so than street art, graffiti is anti-authoritarian, and it continued to take me to places where I would otherwise not go and allowed me to meet incredibly dedicated individuals I would have otherwise never met.

Why does any of this matter? When Banksy commenced what turned out to be his month-long NYC residency under the name "Better Out Than In" he stirred a lot of sentiments, including mass admiration and adulation on social media, a mix of condemnation and breathless excitement in the mainstream press and from art critics, bewilderment among public officials and immediate hostility from many graffiti writers. For the first few days of the month, I thought I could excuse myself from the commotion and just keep shooting graffiti. After all, New York is a big city and there is always new, quality work to be found.

But by around the 5th or the 6th of the month, two things happened: First, my employer informed me that my services would no longer be required. And second, now that I had a lot more free time, old habits kicked in and I just had to shoot each new Banksy piece before it got gone over, boarded up, cut out or stolen. Because that would be the other theme of the month: A constant race against the clock, while somewhere in SoHo, I imagined, Banksy was sipping from an espresso cup at a sidewalk cafe, watching rich European tourists strut their stuff while reflecting on a hard night's work and updating his Instagram feed.

Which gets us back to where it all began: Allen and Grand, on October 1, 2013.

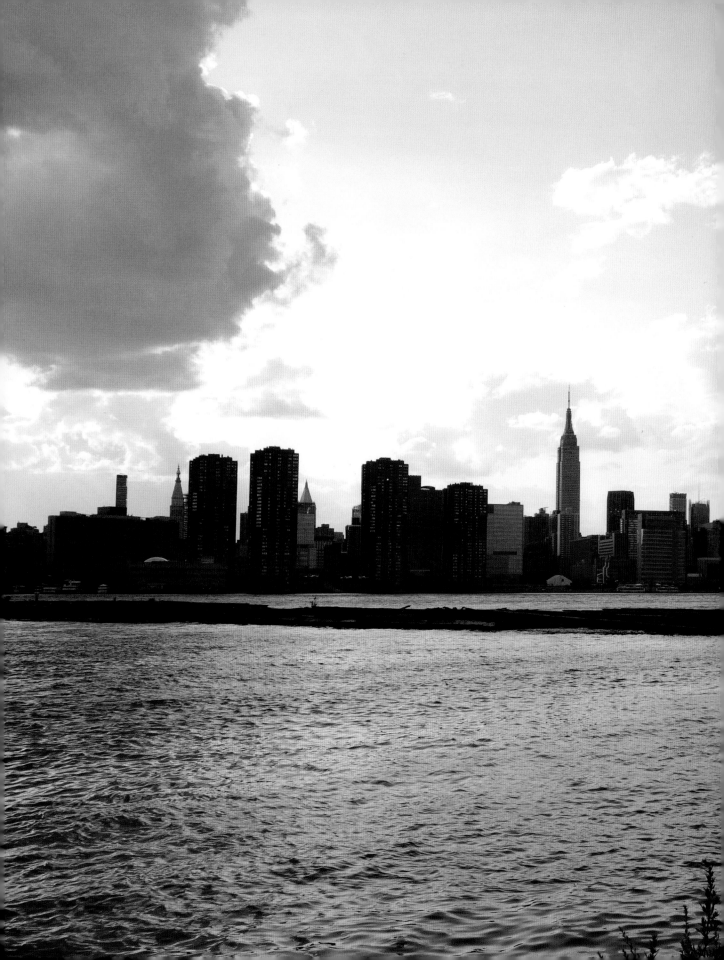

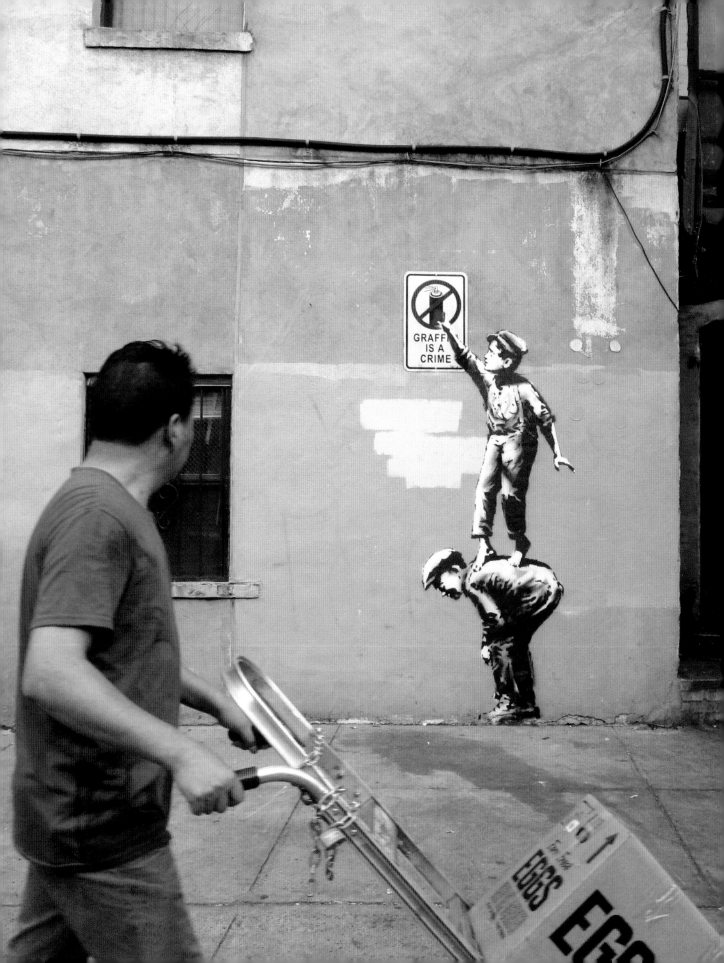

OCTOBER 1: CHINATOWN

"The street is in play."

When I arrived in Chinatown, on Allen and Grand, there was already a flock of onlookers armed with all types of cameras gathered around the image of the two working-class boys reaching for the can of spray paint on an anti-graffiti sign. Word about the piece and its location was apparently spreading much faster than it ever had before for a new Banksy piece in the city.

When Banksy was last active in New York he did a stencil of a bloke putting up smiley posters a block down the street. It lasted for a few days before it got ragged (more about that later) and no one seemed to pay much attention to it when I stopped by to shoot it. Since then, Banksy had been nominated for an Oscar for *Exit Through the Gift Shop* and, thanks to social media, FOMO was spreading like wildfire among the young and the restless. A steady stream of fans arrived in ones and twos, mostly boys and girls in their 20s and 30s, the prime advertising demographic. They had swallowed the bait whole and were now busy calling the 1-800 number stenciled next to the piece to listen to a brief audio commentary recording that accompanied it. I would not have been surprised if the double-decker tourist buses that travel up and down the street started to make unscheduled stops at 18 Allen.

The audio commentary (which would refer to the artist variably as "Bansky" or call him by other, butchered renditions of his moniker) established another theme for the month: Any deep-diving attempts to explain this piece or to identify its underlying meaning in an art-historical context would be potentially futile and possibly self-serving. In any case, you were on your own – the artist appeared to want us to experience each work as a temporary phenomenon, highly specific to and potentially meaningless without its immediate local environment. But of course, no one expects the Spanish Inquisition – sorry – escapes art cricitism. Not even Banksy.

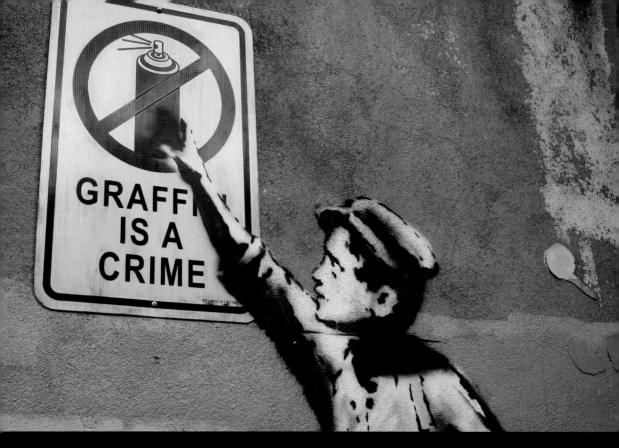

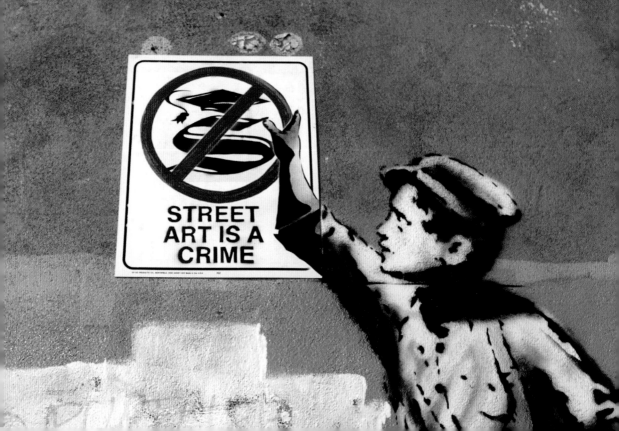

At some point later that night or early the following morning, the sign was first stolen and subsequently replaced by a new sign bearing the Smart Crew logo and the words "Street Art is a Crime." This would remain the most intelligent and thought-provoking attempt any other artists made at interacting with Banksy's pieces. Unfortunately that sign was stolen as well, and few people saw it. Neither sign ever surfaced on eBay. Not long after, the whole piece was buffed with white paint, and law and order were restored to the neighborhood. But by then, Banksy's many-headed horde of ravenous fans had already turned its attention elsewhere.

OCTOBER 2: CHELSEA

While yesterday's piece was general enough in subject and style that it could have worked in any major city of the developed world, today's piece was a clear nod to Banksy's temporary home. Or was he mocking New York-style graffiti? Personally, I always took Banksy for a serif kind of guy, but for expert feedback on his "New York Accent" piece I turned to Christian Acker, aka Handselecta, author of *Flip the Script*, the authoritative guide to North American graffiti handstyles.

"Banksy's New York accent is almost as distinct and authentic as Bugs Bunny's," Christian wrote." The weird irony and mix of symbols and aesthetics is worthy of Banksy and lost on most viewers with less knowledge of the art. It is a loving acknowledgment of the art and culture and style that New York brought the world, but like much most of Banksy's work it seems to be challenging the culture that might fetishize it and be satisfied with staid motifs and styles, especially in a culture of graffiti which was constantly about evolving and pushing boundaries.

"As an imitation of a New York style it is typographically based upon a chisel tip marker tag, with thick and thin strokes and sharp square terminal ends. The fact that it is executed in spray paint and not with a chisel-tiped marker is the first ironic abstraction. The fact that it is then stenciled in spray paint but not freehanded is the second ironic abstraction. Like many free graffiti fonts, it lacks a flow and consistency of good tags (New York-styled or otherwise) The letters lean in different directions and bounce up and down. These are characteristics that work in many freehanded tags and calligraphy, but that are often problematic with fonts, proving so many to be sophomoric. To design a font and to design a tag are different endeavors with different goals. Consistent letter size and lean is essential for a font, and flow and balance is essential for a tag.

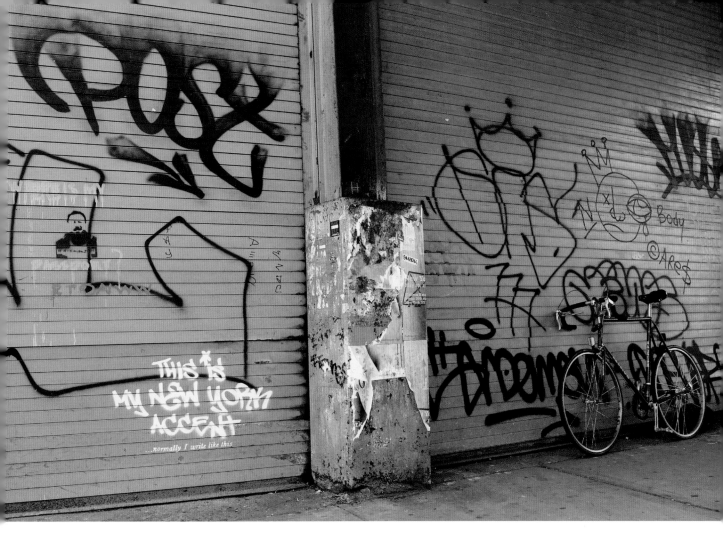

"The fact that it seems as though the starting point was a font that was then customized (or at least used in a upper and lower case combination — see the different Ss, Es and Cs) is the final ironic abstraction. Like most of Banksy's greatest works it is not just ironic, but it is hypocritical and betrays itself, and in so doing points out our own hypocrisies as well. In my own project I am concerned with analyzing and preserving a lot of these folk tales and folk arts of graffiti. Some have criticized me for that. Is it possible I am detracting from the honest goodness of vandalism by making it too theoretical? Perhaps. Perhaps Bansky is too, but he's putting it out there on the walls for others to hate or love and that's something."

The New York Accent unfortunately didn't serve as an object of study and admiration for very long. It was dissed by some kid with a thin marker and later crudely repainted, giving it a nasal twang more closely resembling Long Island than New York City.

This piece, depicting the symbiotic relationship between mammal and hydrant, might have been created the previous day, in the mad rush of adrenaline that followed the illicit stenciling of the New York Accent piece in the heart (or is it the groin?) of the city's art scene. Located just a short walk east of the Highline, near 6th Ave, and strategically placed next to a tight Lewy BTM outline to maximize its exposure, it was first noticed by photographer Luna Park on the evening of October 2. I was still busy at work then and caught it during lunch on the third, along with everyone else in Manhattan who was out for lunch.

Was this a "comical cartoon aimed at providing a small glimmer of light relief to local commuters" or "a structural recontextualizing of the juxtaposition between form and surface" – or something else entirely? Again, the audio commentary provided a multiple-choice response set with no single correct answer.

Perhaps owing to the fact that the wall was already covered in graff, this piece turned into a magnet for spot jocks over the following days and weeks. It deteriorated at the same rate as it was surrounded by lame pasters, stencils and tags, since few artists of note would bother to go near it. Oh well. They couldn't all be home runs.

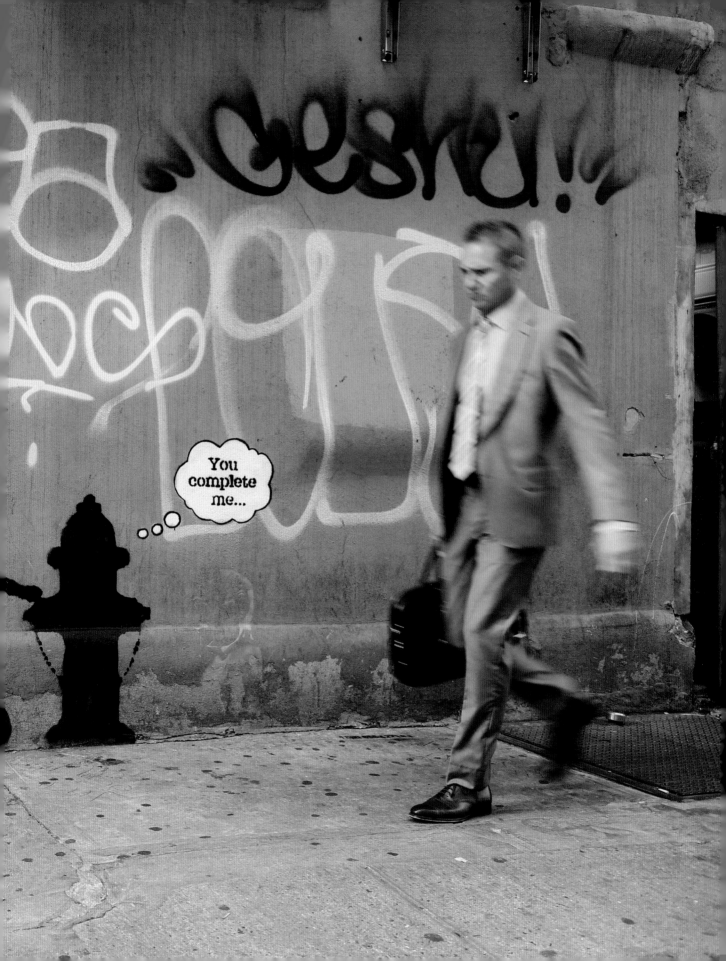

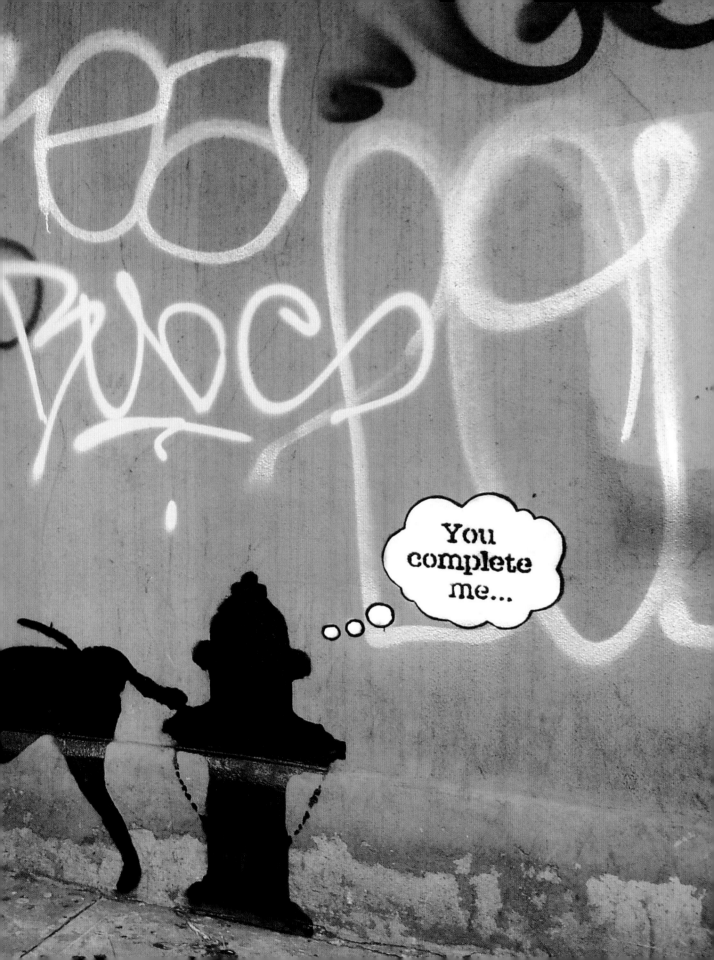

OCTOBER 4:
LES, WILLIAMSBURG, BUSHWICK

When the first three "The Musical" stencils made an appearance, it looked
as if this clever appropriation of existing scrawls on city walls might turn
into a running project. The idea had potential, but the only other Musical
stencil that popped up later, near Cooper Union, was never authenticated.
I also don't quite buy that Banksy just added the stencils to random words
someone had scrawled somewhere with spraypaint. That kind of toy graffiti is
rare in New York these days, given the risks associated with any activity that
is considered graffiti by law enforcement. In any case, all three of the initial
Musical stencils quickly got dissed or buffed (this one, appropriately, by a
member of the BTM crew, aka the Big Time Mobb).

What I *really* wanted to see was an explosion of rat stencils all over the city. Now that would be something. Of course, so much activity would exponentially increase the likelihood that I would stumble upon Banksy by sheer coincidence and catch him in the act. I was totally prepared for that possibility. Without a moment's hesitation, I would approach the man. Feigning complete ignorance, I would reach into my bag and casually ask, "Yo, you write graffiti? Wanna hit my book?"

Presented with the book and a guy who obviously has no clue who he is, Banksy would be motivated to play a little prank on me by stenciling the same Toxic Rat image he just left on a door in the alley in my blackbook, quietly chuckling to himself. And thus I would walk home with my very own Banksy piece, condemned to never being able to tell anyone about it, because, honestly, who would believe me? But I would know. Oh, I would know!

OCTOBER 5: EAST VILLAGE

Intially, in the photos I saw, the Mobile Waterfall truck to me fell into the same category of installation art as a giant Jeff Koons balloon sculpture. It just filled a lot of space. It didn't grab me, and so I didn't track it down until later in the month. The audio commentary refers to the truck ("by the British graffiti artist Bambi") variably as a place of calm and an attempt to compare the act of writing graffiti with illicit farming during the Great Depression. Disowned farmers kept "secret gardens in the weeds," as John Steinbeck calls them in *The Grapes of Wrath*, as a last resort to feed their starving children. The Waterfall truck was neither secret nor peaceful, despite high-tech features such as the "plastic butterflies duct-taped over a fan that move around a bit." So, really not the same at all, as much as graffiti has been known to save kids from lives of boredom, violent crime and depression.

Interestingly, it looked as if Banksy and his crew had also painted the sides of the truck with scrawny tags and a faded fill-in that spelled "Tricy" or "Triky." There wasn't a single tag by a local writer on the vehicle, at least not until it had been parked on the street for a while. Why go through all that trouble to create the appearance of a typical NYC delivery truck? Why not just rent a truck that's already ragged?

Perhaps Banksy felt that it would have crossed a line to drive a truck around the city that carried his work inside while bearing the names of local writers on its shell. Or perhaps he and his crew just felt like letting loose.

It also became apparent on this day that Banksy was indeed working with a big crew whose members must have been sworn to secrecy and with whom he must have been preparing for his residency long in advance. If it wasn't already clear from the dedicated website and audio commentary, Banksy was going to leave little to chance, other than his fallibility as an artist.

OCTOBER 6: DUMBO

The video of a bewildered Dumbo shot down by what appear to be jihadis, anti-government rebels, freedom fighters or figurative representations of adult aggression in a corrupted world, depending on where you fall along the ideological spectrum, generated much speculation and even more YouTube views. Debates were passionate. Some Western viewers, in the throes of patriotic fervor, rushed to voice strong anti-jihad, anti-Muslim and pro-America views (often, it seems, without watching the end of the video). Muslims responded with a defense of their faith; some also professsed their love for the little cartoon elephant and condemned any man-on-cartoon-animal aggression. A few observers attempted more differentiated interpretations, or simply thought it was kinda funny.

Was it a political statement on the war on terror? Or a political statement on the gentrification of the Brooklyn neighborhood of DUMBO? Or a political statement on the vapidness of political statements made by street artists? All I knew was that I had a day off.

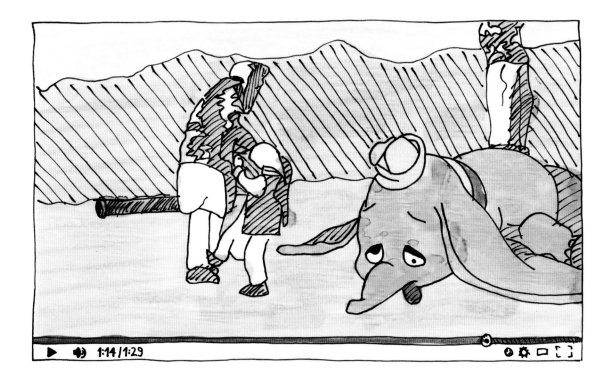

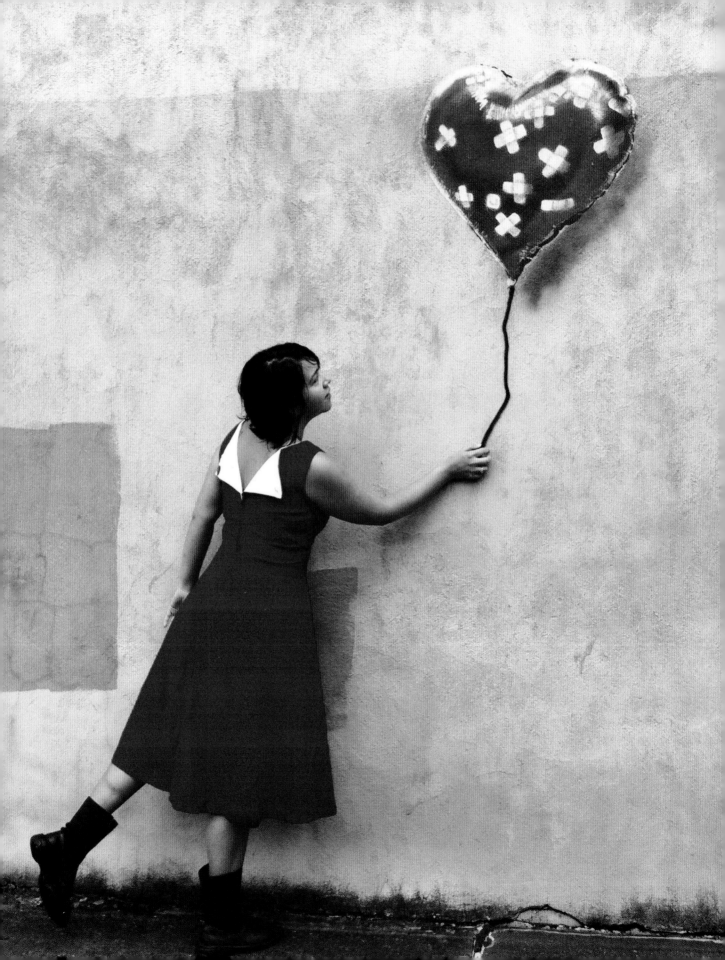

OCTOBER 7: RED HOOK

It was a Monday, and the week started with a bang! Banksy dropped a floater in Red Hook: A red balloon patched up with band-aids. It went down the collective throat of Banksy's followers, whose numbers quickly topped first five and then six digits on Instagram, like warm maple syrup. It didn't even look like a stencil, it looked as if a lovelorn Brit had breathed it onto the wall while listening to *OK Computer* on his Walkman. It was as delicate as a ton of bricks lifted by a swarm of hummingbirds. Crushingly cute. Guys wanted to marry Banksy. Girls wanted to be Banksy. Designers at American Greetings quit their jobs and ran into the streets screaming in the face of the senselessness of their existence.

And then, just as quickly as it appeared, the balloon got crossed out with red paint.

In order to understand what was going on here, we need to circle back a few years. It was the year 2009 and the place was London, England, which some of you may know from weekend mornings on Fox Soccer Plus.

Banksy repurposed what little remained of a 1985 piece by a writer named Robbo located in a tunnel in Camden. Rather than just painting over the piece, he turned it into a tribute of sorts, making it look as if a working bloke was pasting up a poster of the ragged piece. If you had never noticed this spot before, you were sure to see it now, and maybe you'd be compelled to find out more about this guy Robbo and learn that he once was a bona fide king in the game of graffiti thrones. But messing with old pieces by established writers is a big no-no in graffiti, no matter your intentions. It's a massive sign of disrespect, and Robbo was not amused.

The result was beef — a tireless back-and-forth of taking back spots and crossing each other out. Usually, graff beef gets settled in one of several ways: 1) It gets squashed, in order to avert mutually assured destruction, 2) it gets "settled in the street" and someone ends up in hospital, jail, or both, or 3) both parties lose interest for lack of an opportunity to make their move, or because they realize they have better things to do.

However, when one of the parties has achieved mainstream success by veering off the tried and proven path to graffiti fame, the tactical advantage shifts to the aggrieved party. Before the Robbo incident, going over Banksy just made you kind of a dick, a toy looking for a shortcut to fame. Now, if you were on Team Robbo, you could say that you were morally compelled to take Banksy out, regardless of Banksy's subsequent attempts to make amends in the ensuing visual stand-off. It didn't hurt that the publicity generated by anti-Banksy beef resurrected a few graffiti careers. And once you get all that attention, why stop?

As a result, when Banksy last came to New York as part of his North America tour, leaving behind five pieces strewn across Manhattan, Brooklyn and Queens, all of them got ragged within days, and the same pattern set in during his residency, though at a highly accelerated pace. It was a free-for-all for graffiti writers desperate for attention, regardless of whether they had any connection to Robbo or not.

The threat of immediate extinction of a new piece stoked the fear of missing out among Banksy's fans, who hauled ass to find new spots. There was always someone with a camera on the scene before a new piece could be tempered with, and as soon as photos hit social media the mob rushed to get there, myself included. Banksy cleverly played his cards to his advantage. Every day he would get dissed, and every night he would go out and paint another piece. It's hard not to respect that.

I should mention that among the serious graffiti writers I talked to, Banksy is generally respected, if not admired, both for his work and his marketing savvy. After all, graffiti writers are marketers as much as they are artists. No matter though — we had a solid controversy on our hands, and it played out continuously for the next three weeks, fanned daily by new action and counter-action.

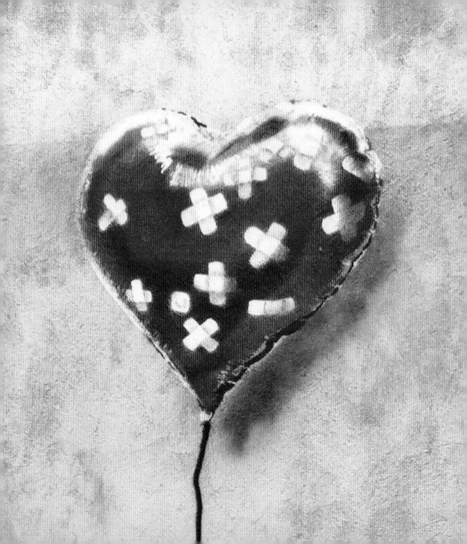

I HAVE A THEORY
THAT YOU CAN MAKE ANY
SENTENCE SEEM PROFOUND
BY WRITING THE NAME
OF A DEAD PHILOSOPHER
AT THE END OF IT

- PLATO

OCTOBER 8: GREENPOINT

The little witticism Banksy left on a Greenpoint door, destined to be
recycled on T-shirts and coffee mugs from now to eternity, was highly
reminiscent of a superior piece he did in DUMBO a few years ago.
Unfortunately it was also gone before most people could catch a glimpse
of it in person, not due to Team Robbo, but because the owner of the door
realized that a financial windfall had fallen into his or her lap. The door was
quickly removed.

Somewhere in the world, that door is now leaning against a wall in someone's
residence or corporate office, securely fastened and preserved. Or perhaps
it's in an art storage vault, never to be peed on or seen again. Removed
from its natural environment, it has not only increased in value, but also
acquired new meanings: It is now a *real* work of art, something to behold
beyond any purpose, a source of understanding of the self in the context of
one's understanding of the canon of contemporary art, and thus a wonderful
vehicle for an ego boost.

It is said that when Banksy and his team were scouting locations for this installation – an interpretation of Pablo Picasso's *Guernica* consisting of a painting spanning the sides of a truck and a passenger vehicle, the obligatory traffic cone coated in paint and a few barrels – they were faced with a real challenge. In a city as densely populated as New York, where would they find a location that was highly accessible by foot and subway, that offered an open, but protected view of the art, and where onlookers – ideally from out-of-state – would be so inebriated, distracted and indifferent at any time of the night that they wouldn't pay attention to a truck, car, cone and barrels being towed into and arranged in a lot surrounded by nightlife?

Banksy and his lieutenants hovered over maps of New York City, moving around push pins. Gowanus? Too remote. Astoria? Too many old ladies screening every movement on their blocks with a finger on their rotary phone dials. Williamsburg? Eww.

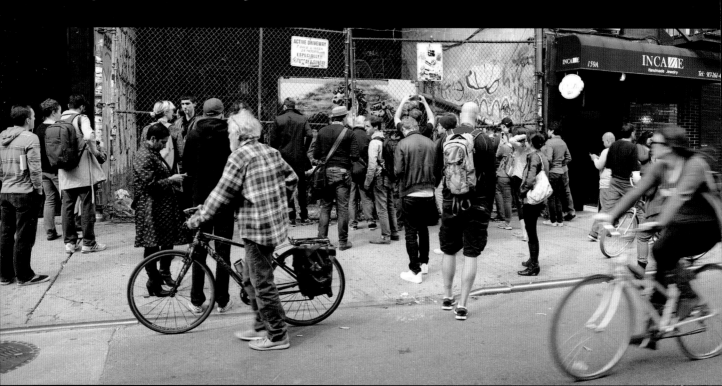

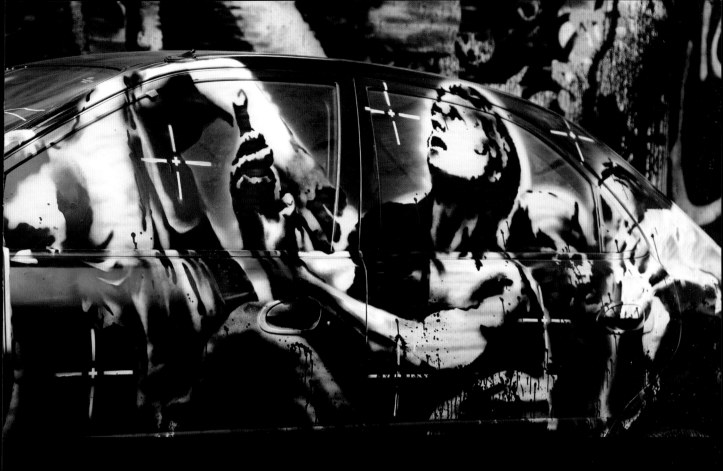

Then, a Euraka! moment. Of course! It had to be Hell Square!

I recognized the lot immediately when the photo was posted on @banksyny. Its walls were covered in fill-ins by Rambo, Sye5, Paste, Ski, Fore, Mint and a few others that had been running for years. This neighborhood, like much of downtown Manhattan, used to have many regular street art and graffiti spots not long ago, and now had very few. This one was secured by a ten-foot fence topped with barbed wire, ensuring that Banksy's installation would be stolen piecemeal rather than all at once.

I lingered for a while, by turns taking photos of the installation and the crowd, and started to recognize the regulars: The skinny dude who took photos for Gothamist. The Dark-skinned guy with long hair, his girlfriend and their little dog. The dude with the silver single speed bike who was about to turn into a minor Instagram celebrity for correctly identifying the locations of several pieces before anyone else. The blonde who took selfies in front of each piece with her stuffed ferret, or whatever that was (what was up with that, girl?). For the rest of the month, these folks became part of the daily experience. We might have had absolutely nothing else in common, but we shared the thrill of discovery and, whenever I could get my head out of my ass, a smile and a greeting.

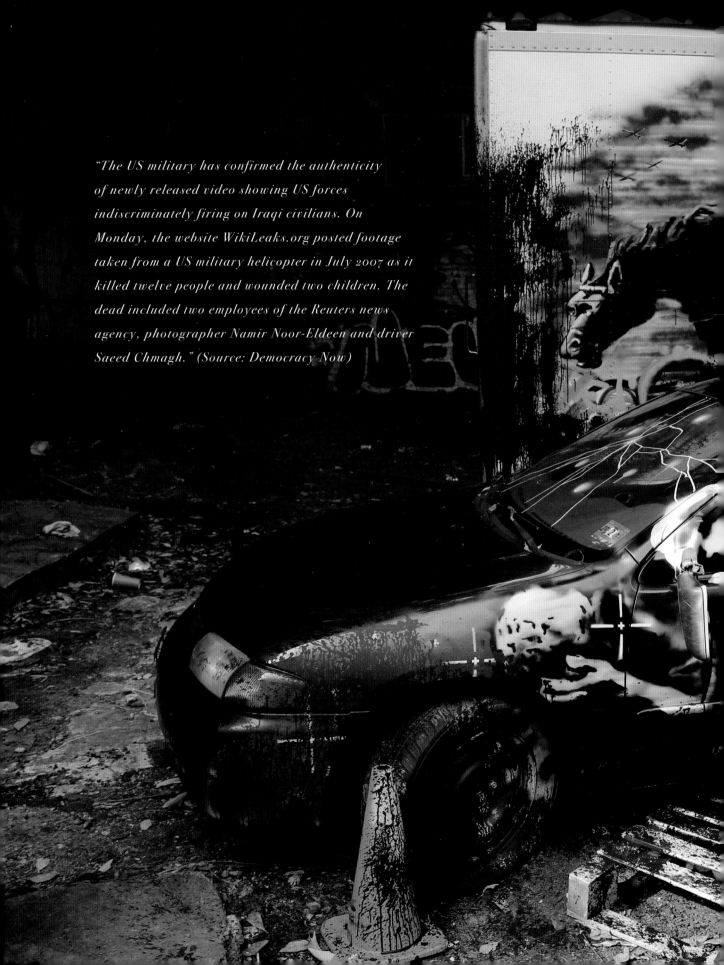

"The US military has confirmed the authenticity of newly released video showing US forces indiscriminately firing on Iraqi civilians. On Monday, the website WikiLeaks.org posted footage taken from a US military helicopter in July 2007 as it killed twelve people and wounded two children. The dead included two employees of the Reuters news agency, photographer Namir Noor-Eldeen and driver Saeed Chmagh." (Source: Democracy Now)

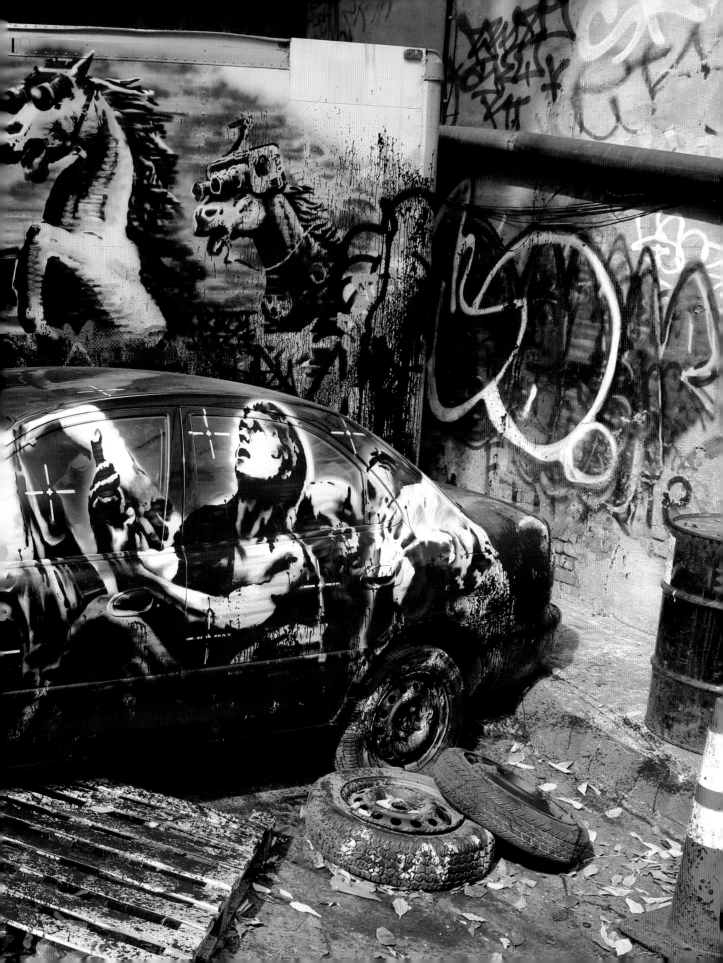

OCTOBER 10: EAST NEW YORK

Silver Single-Speed Guy definitely came through on this one. I made it to East New York in 20 minutes or so by bike after the beaver popped up on Banksy's Instagram feed, but I was still circling the blocks around the Livonia MTA yard (recommended viewing: Rare Easy and Sen.4 fill-ins on shutters plus a smattering of Gusto, Hype and Miss 17 outlines), when he had already locked down the exact spot on a completely random corner in the middle of the neighborhood.

About 10-15 people were gathered in front of the piece, a stencil of a beaver who appeared to have felled a utility pole. The pole lay against the side of the building, indicating that it had not originally been standing there. (Utility poles in New York are always installed street-side on sidewalks. Their utility consists chiefly in serving as a receptacle for silver marker tags and as makeshift bike racks.) Half of the onlookers appeared to be from around the neighborhood, including three or four guys in workmen's clothes, while the rest formed the vanguard of Banksy's fan expedition.

The general mood was cheerful. Skinny Gothamist dude and Long-Haired Hispanic guy were already there and we took turns taking photos of the piece and the scenery. Someone mentioned how the wall was now worth a ton of money, which set off a lengthy, skin-scratching, hemming and hawing discussion among the working guys about the best options for cutting the piece out of the wall. Thankfully that discussion was cut short when a woman suggested that any attempt to remove the piece would lead to its destruction, leaving everyone worse off. The guys agreed grudgingly. I suppose it's easier to let go of a treasure when you were never quite sure whether it was a treasure, or your treasure, to begin with.

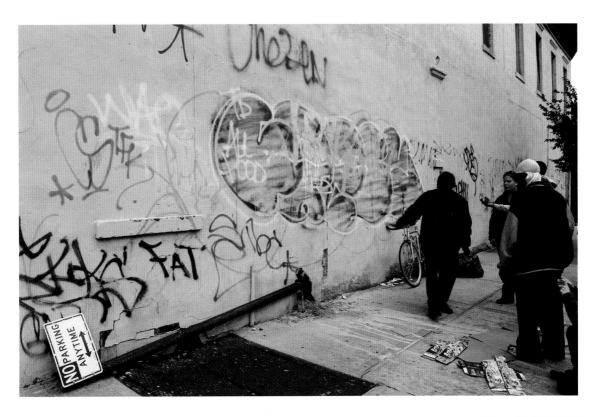

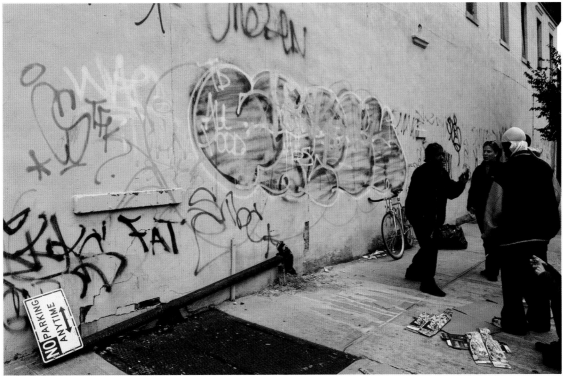

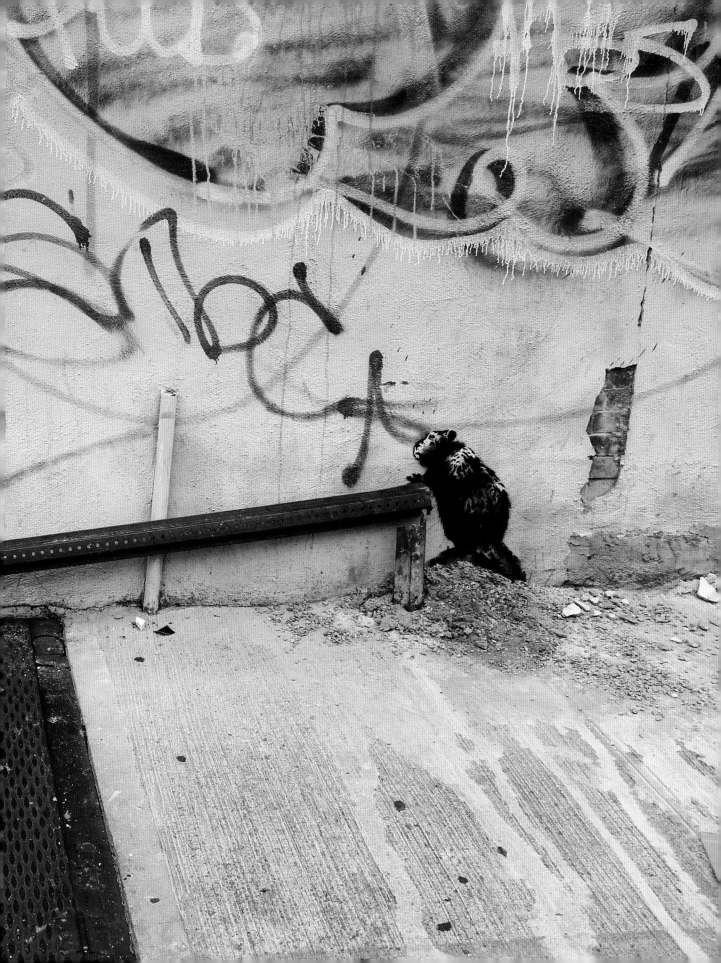

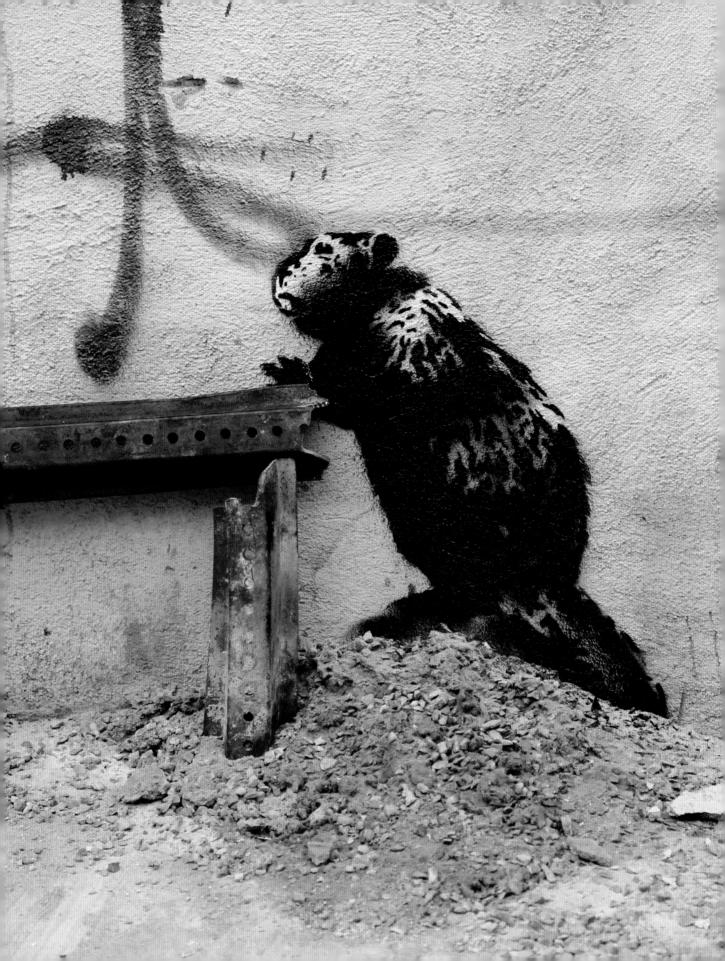

Just as I was leaving, one of the Banksy fans jokingly remarked that the guys should charge people to see the piece. And that's how, for the rest of the day, everyone who wanted to take a photo had to fork over up to $20.

There was much condemnation and indignance on social media afterwards. This was Banksy's "gift" to New Yorkers, how dare these (black, presumably low income) guys charge people to see what is supposed to be in public view? But I really can't blame them. Gotta respect the hustle.

In the past, particularly in New Orleans and along the wall separating Israel from Palestine, location was critical for the success of Banksy's pieces. In this instance, I'm not sure whether he wanted to make a statement about race and class. Certainly his choice of location was not meant to be charitable. He probably wanted to preempt critics accusing him of a preference for whiter, higher income areas by spreading his work around the city (and of course "going all-city" was part of the bigger plan). Locations like this certainly made the egg hunt more interesting, and while the social experiment was only a by-product of the choice of location, that narrative dominated public discussion – an ideal outcome for Banksy.

Ultimately, the message Banksy is trying to convey with this piece is easily decoded: The beaver obviously stands for the people, and the utility pole stands for "the government" (whatever or whoever that is - note that the terms are mutually exclusive; if you are in "the government" you cannot – CANNOT – also be one of the people, that's just not how this works), which has grown much too large and bureaucratic and has been taken hostage by special interests (i.e. bicyclists and kids with silver markers). By cutting down the utility pole, the beaver re-asserts his will and prepares the ground for the day when the aliens will come and rescue those among us who are willing to live free and die hard just ahead of the demise of the planet from its collapse into a black hole accidentally created at CERN. Obvi.

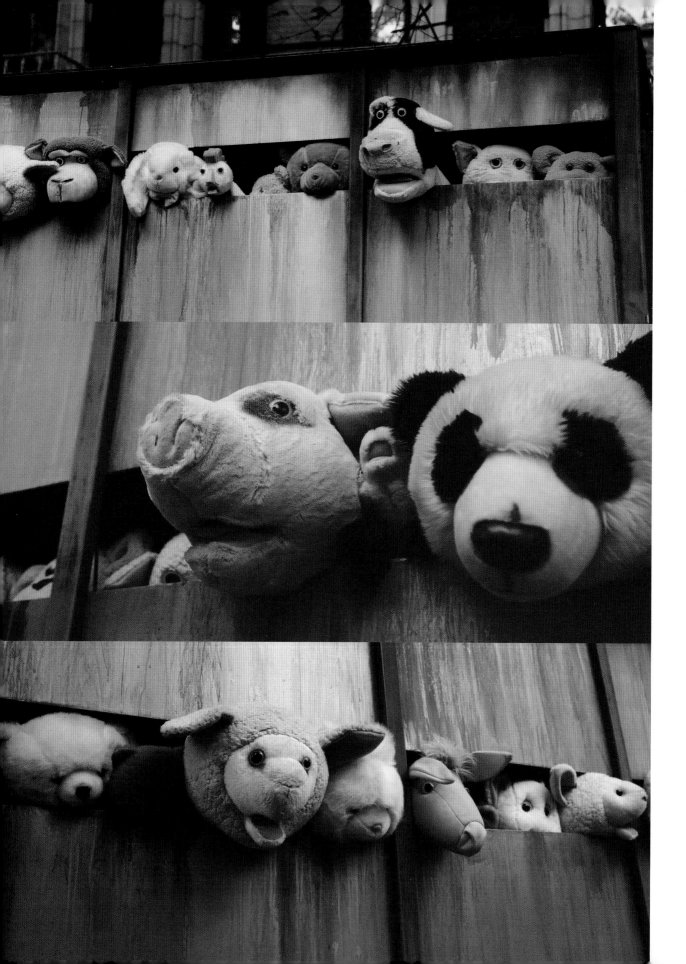

OCTOBER 11: MEATPACKING DISTRICT

The Sirens of the Lambs truck, a terrifying contraption created to induce screaming fits and nightmares in small children, was first documented on Instagram a day or two prior to its official launch. Its most endearing feature was the driver. What a nice man! While I noticed that he had a British accent and in height and stature resembled the man shown in what is purported to be the only photo of Banksy, I will not engage in any speculation as to who he really was. After all, at any given time, there are thousands of British lads in the city, preying on NYU students with their outlandish accents. (Yeah, that's right — we refer to what you call "English" as an "accent," and don't even get us started on your teeth. Colonizers.)

Anyway, this guy was a peach. He patiently answered questions and posed for photos on his coffee break. He even waited to pull out into traffic until Ferret Girl had finished taking photos of her critter wedged in between the other animals on the back of the truck. As a roving installation, the truck itself was perhaps the most "finished" piece of the month. Even art critic Jerry Saltz reluctantly admitted that it conveyed "surprise, pathos, and humor," which was probably the nicest thing he said about any piece of art in 2013, and the only nice thing he said about Banksy. And he probably didn't even meet the driver.

According to the audio commentary, "in order to bring [the cuddly, soft toys] to life, four professional puppeteers are required, strapped into bucket seats, dressed entirely in black lycra, pulling on an array of levers with each limb and given only one toilet break a day, proving that the only sentient beings held in lower esteem than farm livestock are mime artists." I couldn't find any evidence for the presence of sentient beings in the back of the truck, so I can only assume that this statement is a metaphor meant to illustrate the rise and fall of the American automobile industry as well as the inability of our leaders to do anything about the monopoly a certain coffee chain has on public restrooms.

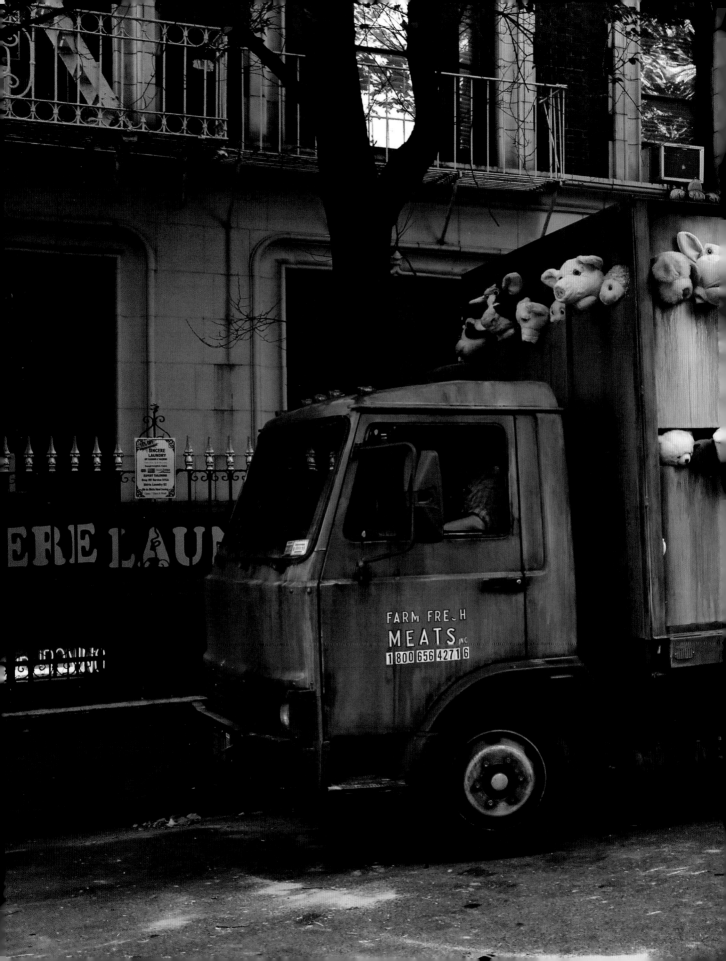

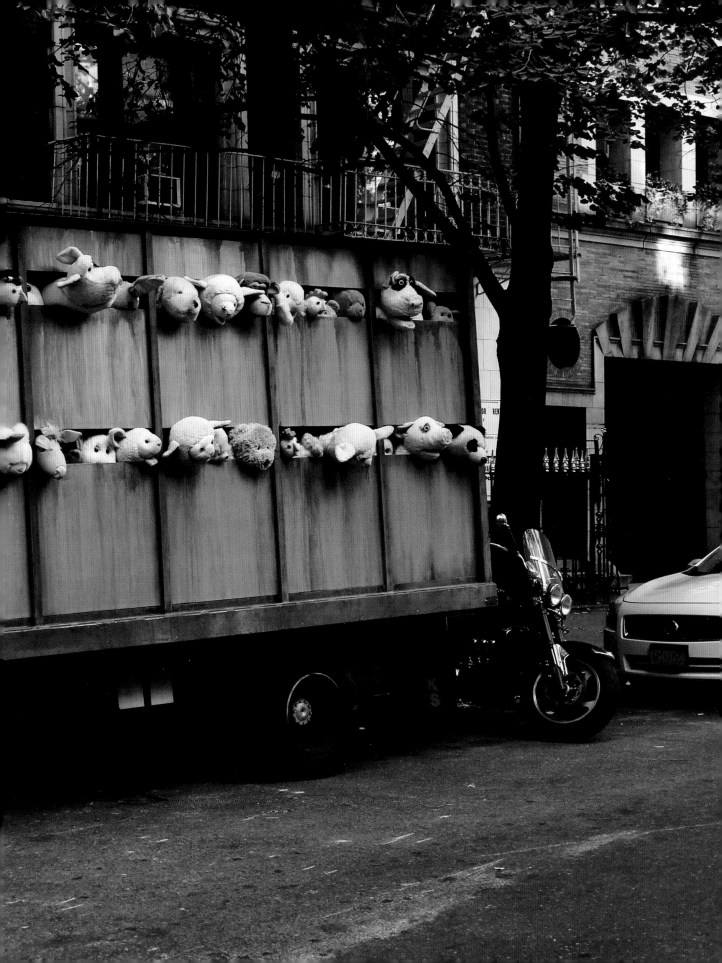

OCTOBER 12: COOPER UNION

The Concrete Confessional piece was the first genuine found-object piece of Banksy's residency, and it succeeded in very quickly shutting down traffic on 7th Street due to a large crowd of onlookers, including all of my regulars, who were snapping photos and waiting for anything out of the ordinary to happen. And, behold, it did! A skinny guy, accompanied by anxious screams and threats, jumped into the concrete shell that harbored the stencil of the priest taking confession. Moments later, he emerged from it with what looked like a possible fragment of the stencil itself, likely drenched in human urine and excrement. In the midst of all that commotion, a middle-aged guy with glasses who I had seen around one or two of the other pieces stole around to the back of the concrete block and wrote something along the lines of "Banksy wuz here" on it with chalk. His British accent was no bueno though. Banksy-pretend fail.

Due to its location and theme, the confessional got ragged, repaired and complemented with numerous additions practically overnight. I have to confess that my favorite thing about it was its proximity to the watering holes of my student days around St. Marks Place. We were frequent visitors there, and in the haze of night discussed Derrida, Husserl and Adorno, dissected postmodern culture, critiqued the inherent elitism of the notion of high art and most certainly would have scoffed at the walking cliche of a stencil artist painting an image of a priest in the East Village. We danced, we drank, and we loved. Ten years of failed attempts at adulthood and many watering hole visits later, Banksy stencils were all that was left, and we wept.

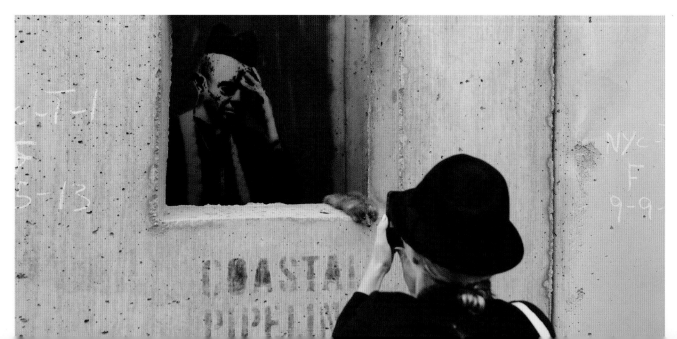

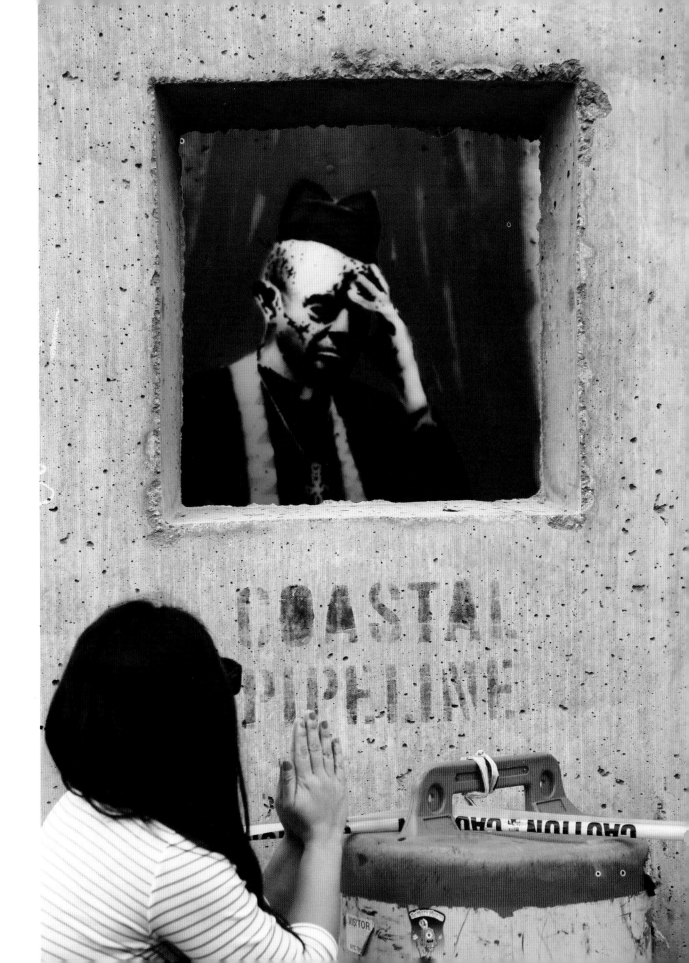

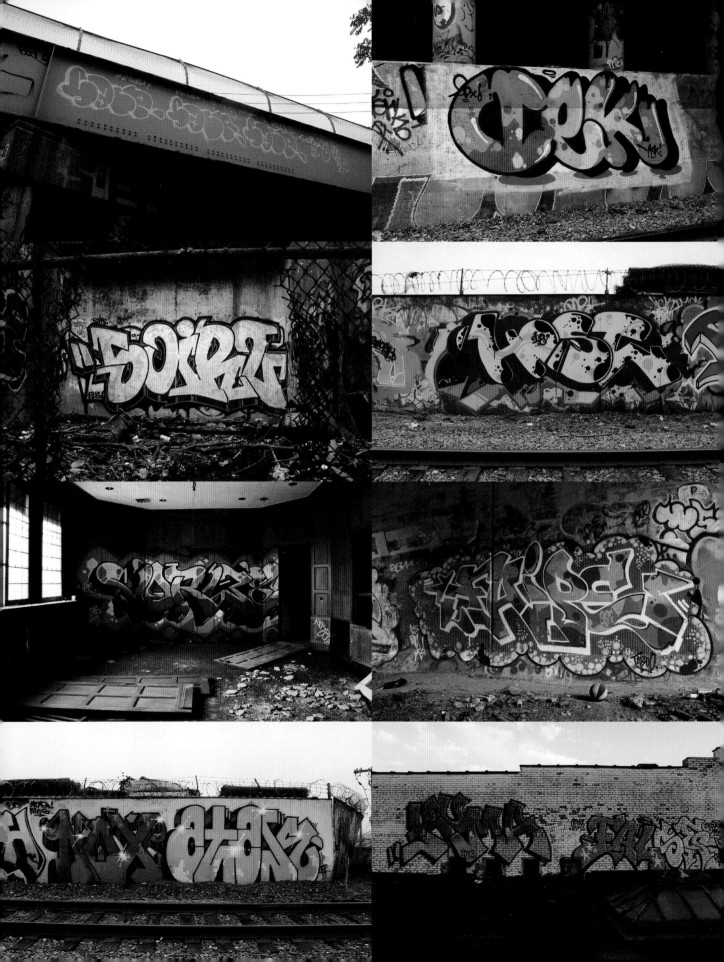

OCTOBER 13: CENTRAL PARK

It was a Sunday, and all morning, throughout brunch time and into the early afternoon, I kept checking back for an announcement about the day's piece. However, no news was forthcoming. I kept myself busy by shooting graff in remote Brooklyn locations with a few friends. It was a nice day, and there was only so much time one could spend hunting down Banksy pieces when there was so much else to do in New York City.

I definitely wasn't about to waste time by heading Uptown to scout the area around Central Park. There was no graffiti or street art there. None whatsover. No way was Banksy going to attempt any sort of stunt in the middle of the city. Maybe he looked at the balmy October sky and decided to just take a day off himself.

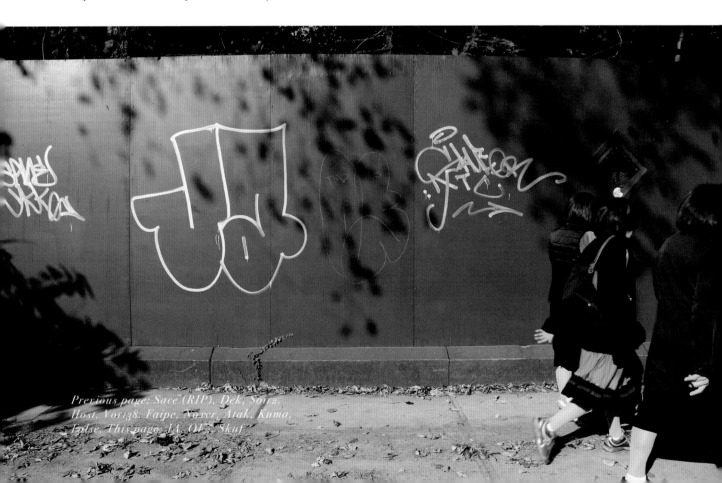

Previous page: Sace (RIP), Dek, Soire, Host, Vor138, Faipe, Noxer, Atak, Kuma, False. This page: IA, OE, Skuf

▶ ⏸ 0:47/2:51

Alright, so I was wrong, big whoop. Honestly, if I had gone to Central Park on Sunday and seen the stand where an old geezer sold original Banksy canvases worth hundreds of thousands of dollars for a few bucks, I would have kept walking. The traffic cone, visible in the video of the three sales that took place, was a bit of a giveaway, but I likely would have missed that, too. This stunt was meant to be contemplated only in hindsight. In fact, I wonder what would have happened if anyone had voiced any suspicion on social media that the stand was for real, and folks had bought it out on the off-chance that the work was genuine. Would Banksy have denied its authenticity?

I don't think that the idea behind selling original artworks for a pittance was to make people rich, or to make them angry, or even to shine a light on the difference between the material and perceived value of contemporary art. It was simply designed to make you wonder, what if?

It's like any other lottery: You don't buy the ticket because you think you are going to win, but because it allows you to dream about all the things you could do if you did. If you look at it that way, the Central Park stand was a gift of bad fortune, allowing us to wonder aloud how differently our lives could turn out with only a small stroke of luck. I got some great shots in South Brooklyn that day, so I was happy anyway.

OCTOBER 14: WOODSIDE

Today was an opportunity to log a few more miles on the ol' bike, since the day's piece was in the middle of Queens. The format of the piece wasn't all that new. It was a variant of the generic working bloke erasing a gooey, positive message, reminiscent of the Cancelled Dreams piece from Banksy's stop in Boston on his tour across North America or the tribute pieces of sorts to the vigilante known as the gray ghost in New Orleans. In this case, the image was of a cleaner erasing a quote from the movie *Gladiator*.

I leave it to you to ponder its artistic merits. By now any new piece was bound to attract crowds, even on a Monday morning. Word was that someone had seen two men pull up in a van and work on the wall behind a tarp very early in the morning, thus setting the stage for a witch hunt on blue tarps. From now on, no working bloke was safe from suspicions of being Banksy.

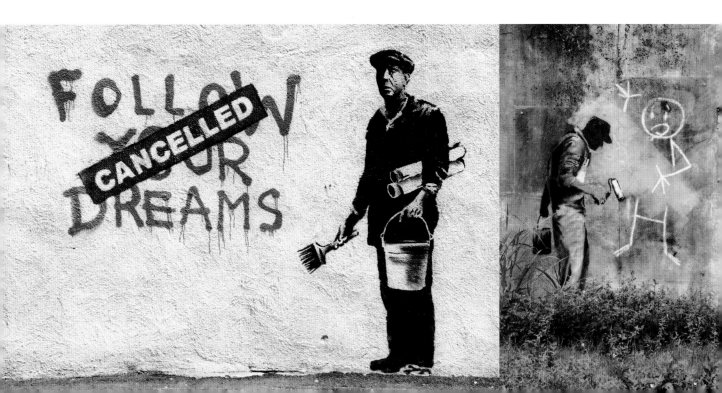

What we do in life ech

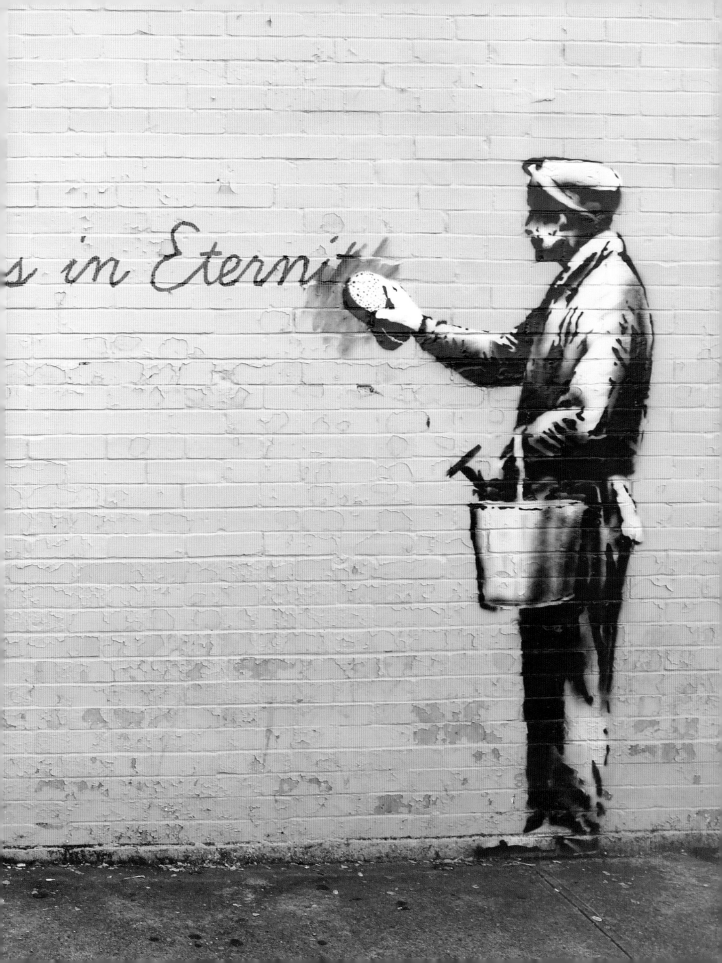

I was in New York on September 11, 2001. I remember the collective trauma and the gradual awakening from it, down to the painfully slow process of rebuilding downtown. And frankly, I'm not sure that, after twelve years of public discourse in the aftermath of the attacks, I needed to be reminded of them any further. But Banksy's simple representation of the downtown skyline with the twin towers and a blooming flower attached to one of the towers roughly near the level of the building where the first plane hit was whimsical and touching, and just small enough in scale not to be drawing too much attention to itself from the disaster.

As I was taking photos of the tribute in Tribeca, a man rode up on a scooter, walked up to the piece and sprayed some sort of 9-11 Truth message next to it. He never took off his helmet or identified himself. That act felt incredibly violent, even among the contrived tranquility of a flock of New Yorkers gathering around a Banksy piece. Here was someone who had so thoroughly convinced himself of the righteousness of his quest that any alternative narrative had to be part of the conspiracy to suppress the Truth.

My personal rule of thumb (warning: run-on sentence!): Reducing complex real-life conflicts with a multitude of actors, interests and motivations to any dichotomy (good vs evil, truth vs lie, right vs left, the government vs the people, etc.) will likely give you the explanation you already believed was true, but it won't give you a differentiated understanding of the underlying conditions of human goodness or depravity. Understanding without self-understanding is no understanding at all. But don't let me tell you, you figure it out.

The scene in Brooklyn Heights was a lot more chill and appropriately peaceful, with only a few people stopping for photos and the breathtaking view of downtown Manhattan that never gets old. Unfortunately, since the Brooklyn tribute was on city property, it was removed very quickly.

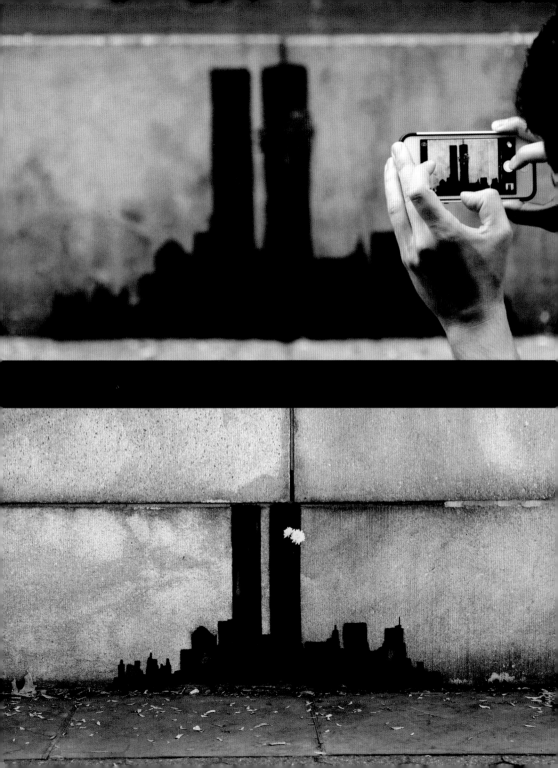

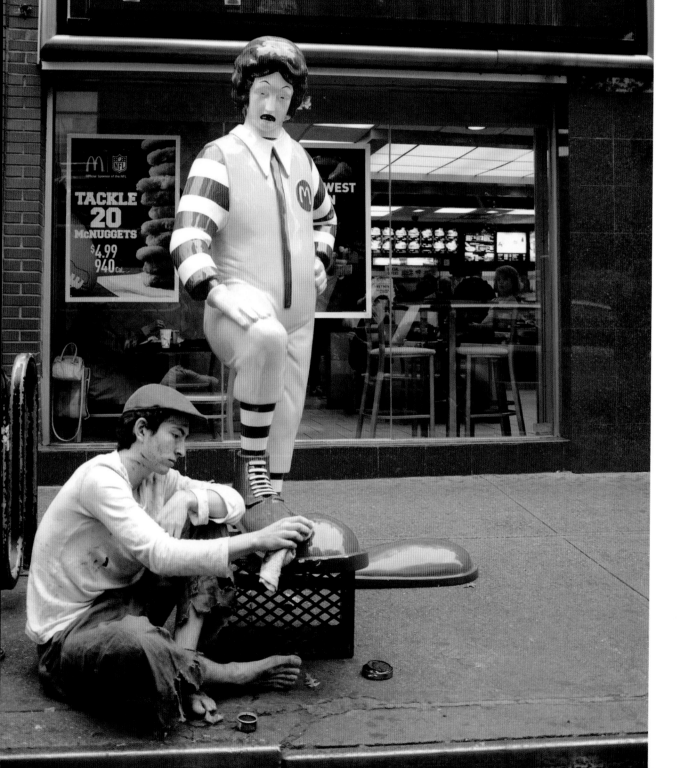

OCTOBER 16: THE BRONX

I knew that sooner or later I would have to make one or several trips to the Bronx to shoot Banksy pieces before the month was over. But not today. I couldn't get excited about the image of an actor polishing evil Ronald McDonald's shoes in front of one of his namesake fast food restaurants. Is McDonald's, for all its flaws, really still the prevailing symbol of American capitalism, or is it just a more convenient target than the big banks and hedge funds, Facebook, Google or the NSA? But I suppose if you are looking for overt symbolism, you might as well start here.

For once, the audio commentary was unambiguous in explaining the piece, calling it "a critique of the heady labor required to sustain the polished image of a mega corporation." Indeed, the biggest flaw of this piece was that it didn't allow for any alternative interpretation.

However, the Ronald McDonald piece gave us something else that we have come to expect from ensemble movies and comedy shows in the form of one of the two actors hired to play a shoe-shine boy: The black cast member.

Alright, alright, that was too easy. Nevermind. I've got nothing. Move along.

OCTOBER 17: BUSHWICK

I'm not sure what took them so long, but today the NY Post finally graced its cover with a story about the hunt for Banksy (although, to the best of my knowledge, no property owner had actually filed a complaint). Even the outgoing mayor, Michael Bloomberg, weighed in with steadfast condemnation of Banksy's vandalism. That should have been plenty of fodder for the public imagination, but events quickly took another turn.

A crowd consisting largely of neighborhood residents, store workers and shoppers in Bushwick (aka East Williamsburg, in broker babble) was giddily taking photos in front of the Japanese Bridge piece, some learning for the first time about Banksy's ongoing project.

Then, out of nowhere, a masked, self-styled anti-street art guerrilla pulled up to the piece and started to go over it with black spray paint. What ensued was variably described by social media users (who largely hadn't actually been there) as either a vicious beatdown or a justified defensive act. Those who felt the need to identify themselves with Team Robbo or the pro-Banksy camp quickly took hardening positions, ranging roughly from "clueless hipsters beat up the righteous graffiti avenger" to "this is what happens when you try to fuck with a Banksy piece."

Here's what actually happened: Our masked avenger was pulled away by one or two guys who were standing next to the piece, just far enough to keep him from further damaging it. One of the guys wore a button-down shirt and slacks; I believe he was the manager of the store on which the piece was painted. There was a little light shoving; imagine a bunch of pre-schoolers in a mosh pit. So far, no hipsters were involved.

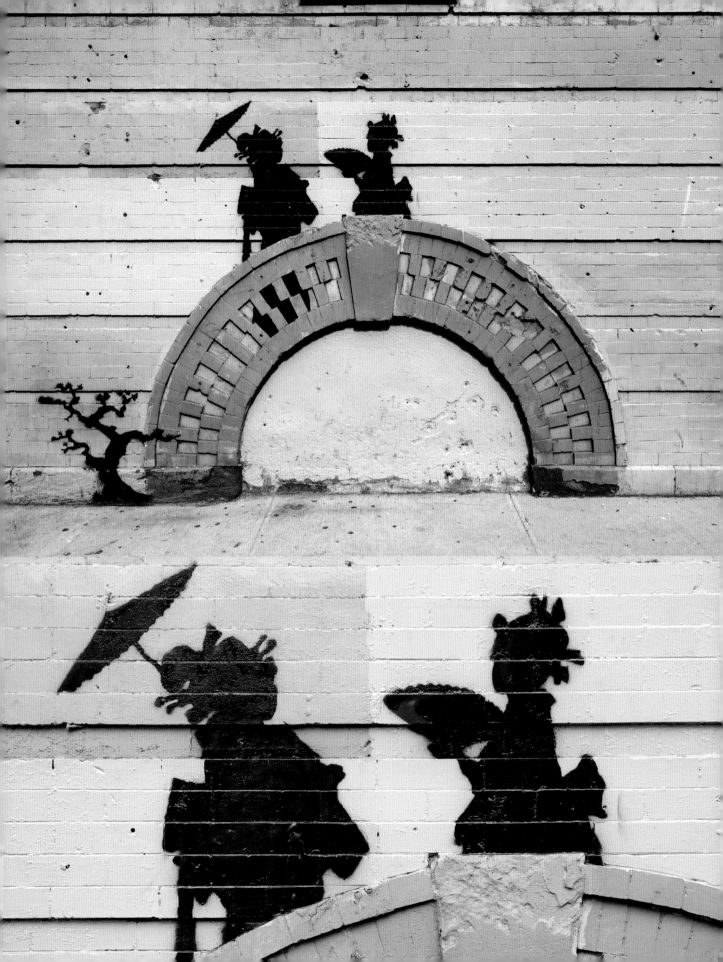

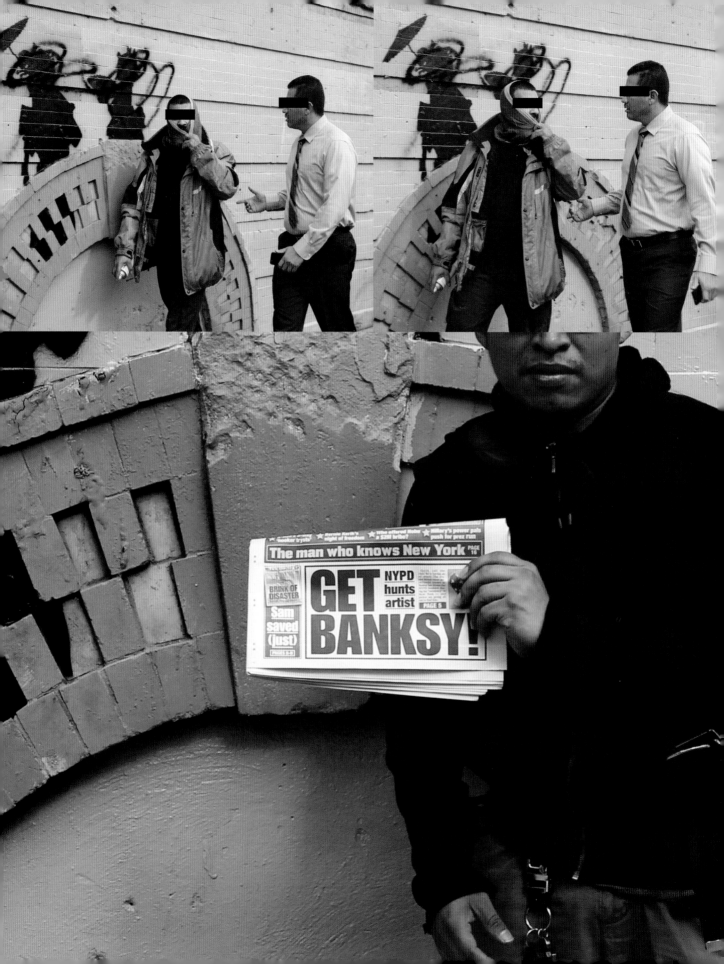

At some point in the melee, Guerrilla Dude pulled off a move I've only previously seen performed by Buster on *Arrested Development*. Without actually being hit or kicked, he let himself sink to the ground, curled up into a ball and covered his face. People weren't sure what to do next. Someone called the cops. But the most natural reaction was to pull out your smartphone and take photos of the guy on the ground. Thus what was really a fairly uncoordinated and harmless confrontation became a "beatdown" on Instagram. (Fair disclosure: Some of the photographers might have been hipsters. It's hard to tell, since I believe the term has basically come to mean "any young-ish person living in a city who does something you don't agree with." God, I hate them!)

A few seconds later, the guy got up and simply walked away. It seemed like he would ride off, but he turned around and surveyed the scene again from across the street, boasting that he was "the guy who has been going over Banksy everywhere." He seemed quite pleased with himself. And he might as well, since he never achieved any recognition as a graffiti writer before or after. Meanwhile, the crowd resumed posing for photos. Eventually someone brought paint thinner and the piece was quickly restored to something close to its original condition.

One more thing of note: The idea of installing a roll-down shutter in front of a Banksy piece in order to protect it until it could be cut out of the wall and auctioned off was pioneered here, to my knowledge.

The piece also garnered art world criticism for closely resembling the work of the immensely talented Kara Walker. I would submit that Banksy has utilized the silhouette style in various pieces for many years and across the world, and in this instance his use of the existing building structure was crucial to the success of the piece.

For all of the planning that went into his NY residency, I'm almost willing to believe that he came up with this one on the fly. The execution is technically flawless, giving the appearance of simplicity and depth to what is really a unique mash-up of art historical influences and real-world context. And unlike some of the other pieces, there was something about it that made most people who saw it and who posed with it unequivocally happy, regardless of whether they had any idea beforehand who Banksy was or not. That's good enough for me.

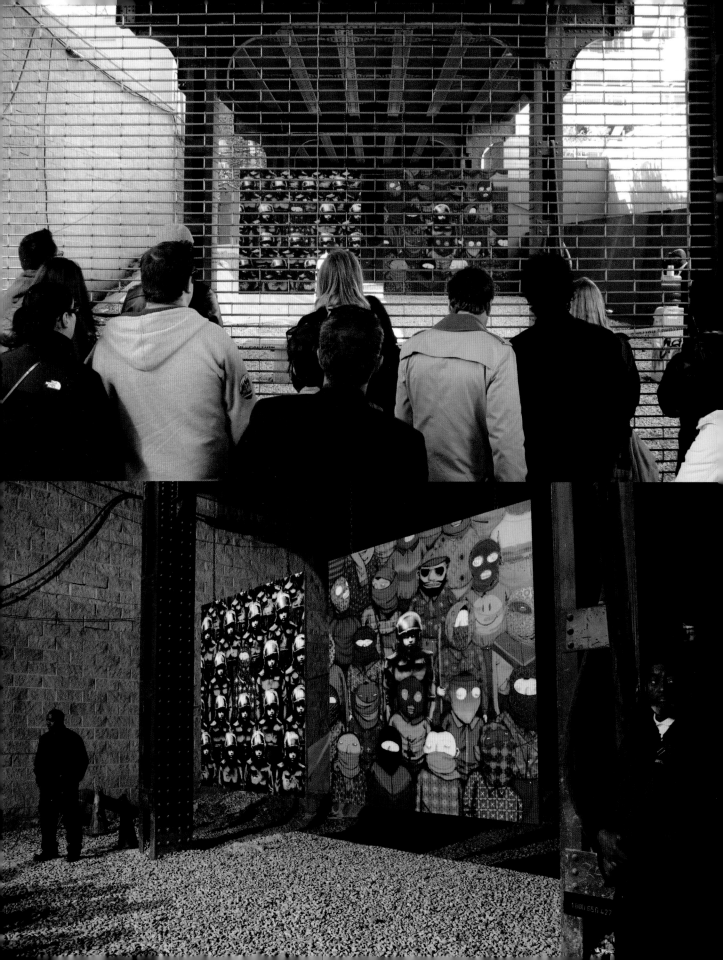

OCTOBER 18: CHELSEA

The pairing of Banksy with Os Gemeos, the Brazilian twin brothers who are among the very few artists with a graffiti background to have continued to successfully straddle the art world and the street, was guaranteed to be interesting. Banksy's interview with the Village Voice (which featured alternate covers bearing the Banksy and Os Gemeos images to coincide with the installation) didn't reveal any shocking news about the artist, whose real name is as well-known as it is irrelevant, but it added another layer of texture. And while the installation and the interview were both very accessible, the art and the creator himself continued to be fully secured from public intrusion.

The audio commentary suggests that this piece functions both as situational criticism of the art world as well as a tribute to the Occupy movement. Yet it also recognizes that the installation may be unsuccessful at actually advancing any agenda.

On a side note, the traffic cone made yet another appearance with this piece. How many traffic cones does Banksy go through on average in any given year? I remember that one of the deans in my high school chewed through two pens a day after he quit smoking. Did the traffic cones fulfill a similar function in Banksy's everyday life? Regretfully, the Village Voice either did not think to ask this question, or it was screened out and remained unanswered. We'll never know.

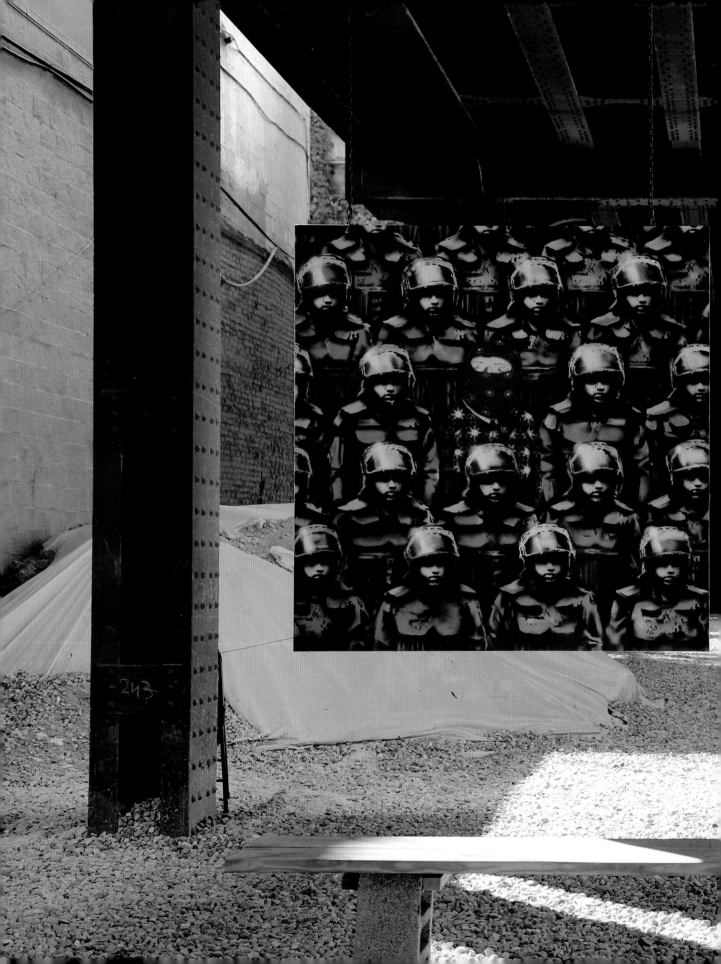

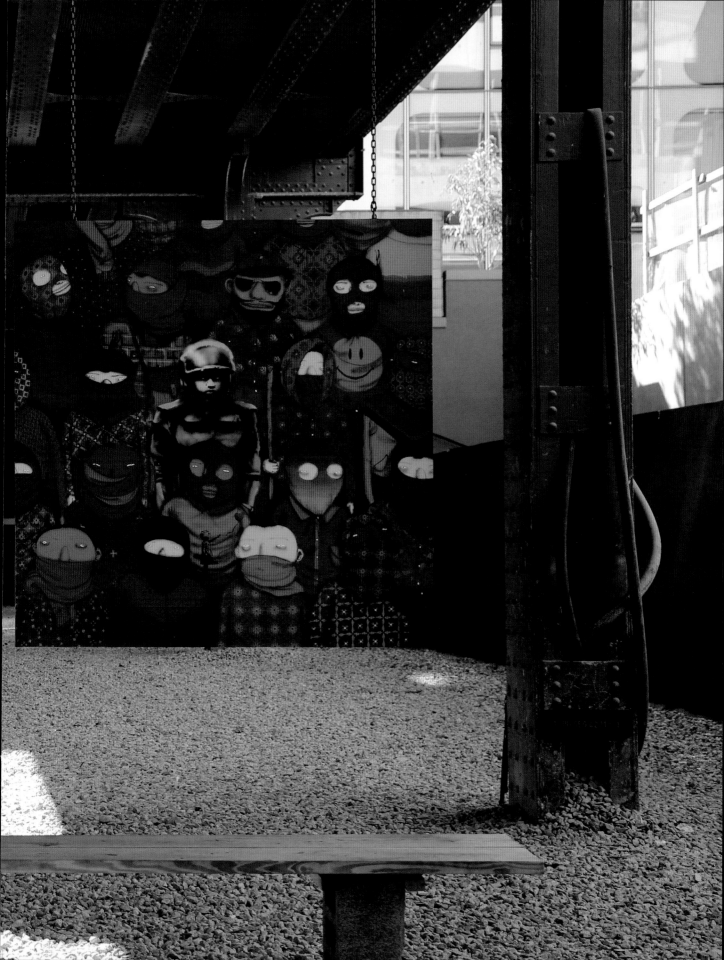

OCTOBER 19: STATEN ISLAND

I can't remember if anyone actually found the spot where today's video was filmed. The artist might like you to believe that this piece was an abstract rendering of nature in a state of flux, but it was actually just a vagina with ants crawling out of it.

On a completely different subject, I imagine that, for some people, mingling at Banksy pieces was a great way to meet members of the opposite or same sex. I could hear their conversations every day:

"Did you see Exit Through the Gift Shop?"
"OMG it was hilarious."
"I actually met Mr. Brainwash once, like, three or four years ago. He was putting up posters on the Bowery, so he is definitely not just a product of Banksy's imagination."
"Oh cool. One of my friends is one of Matthew Barney's assistants."
"I love Bjork! Are you busy later? Wanna grab a drink?"

I imagine that in July of 2014 a wave of Banksy Babies was born across New York, and I sincerely hope that their parents will do the right thing and buy them three copies of this book, so that they may always remember whence they came.

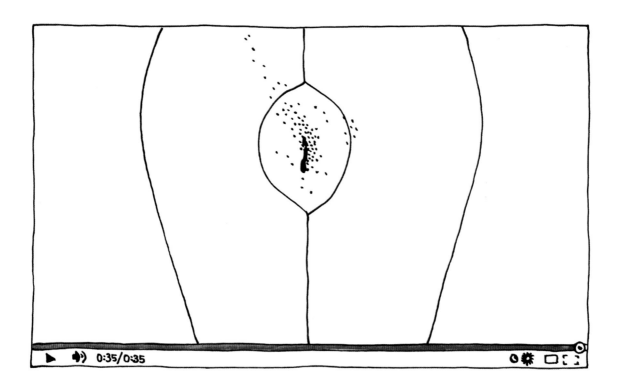

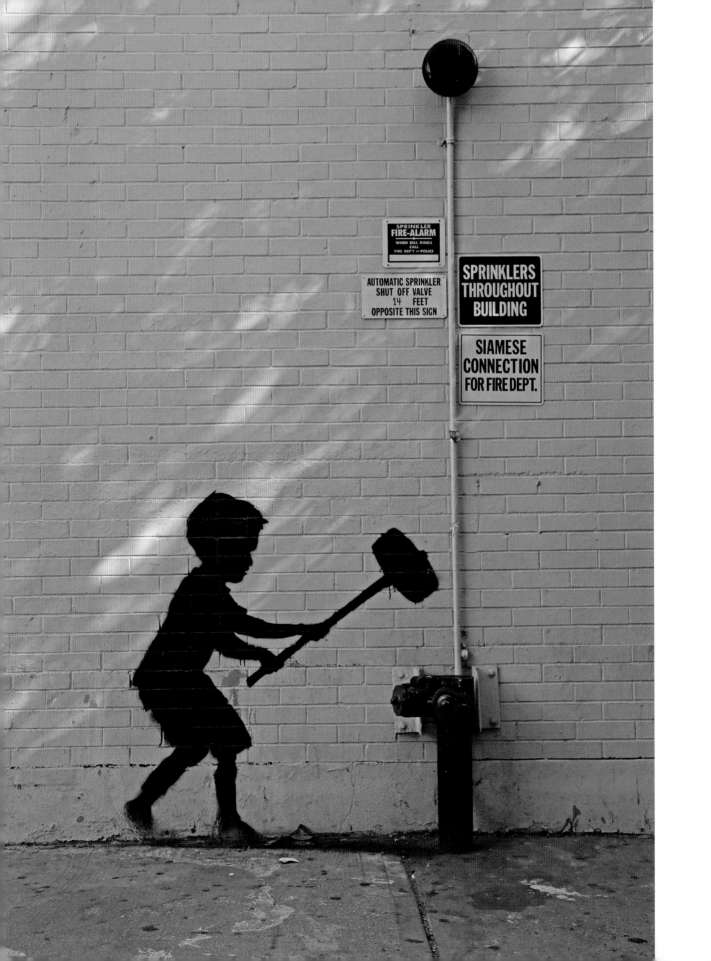

OCTOBER 20: UPPER WEST SIDE

Not only was today's piece another clever appropriation of a found object, but it also uniquely lent itself to audience interaction and countless posed shots. And there sure are a lot of young children and small dogs on the Upper West Side, based on my unscientific observations on a Sunday morning.

Also present were two photographers I admire very much: my friend Luna Park, who has been an integral part of the New York street art scene for many years, and the relentlessly inspiring subway graffiti documentarian Martha Cooper. Not to be outdone by the local kids and dogs, they struck a pose with Banksy's piece, and I was fortunate to take the photo.

With this piece, we also got the first indication that Team Robbo might be running out of steam. There were a few half-hearted attempts to rag the stencil on subsequent days, but by then it was already protected by plexiglass. Someone later produced a wonderful animated GIF of this piece, thus fulfilling its destiny. It's cute, google it.

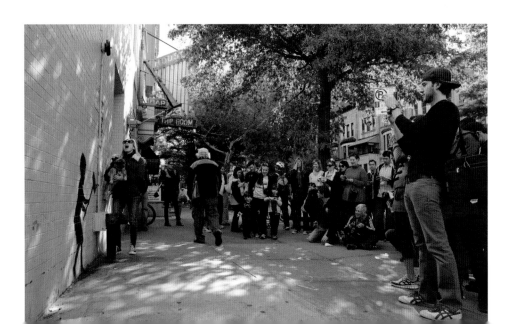

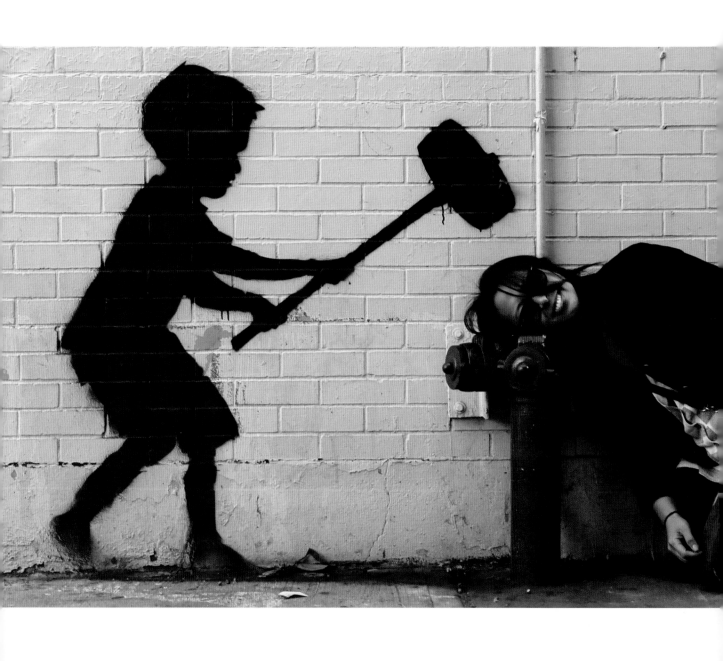

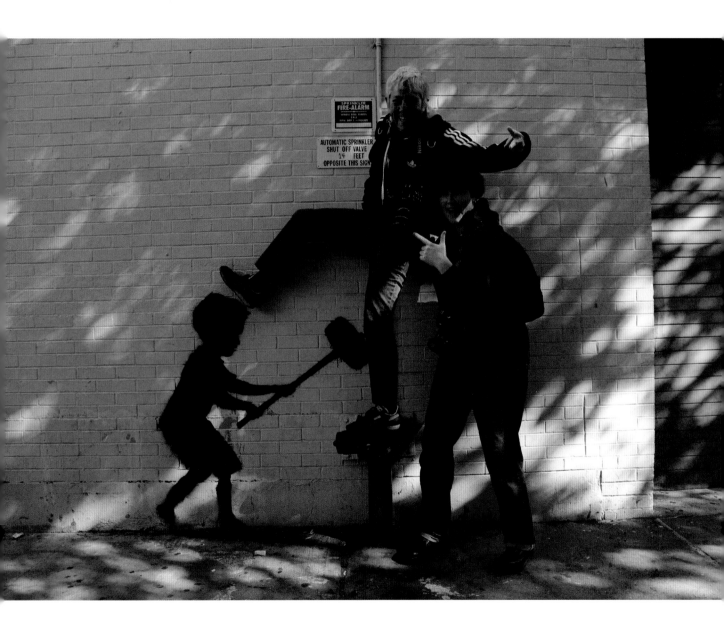

I cheated. I wasn't able to get to the Bronx until later in the afternoon,
so I made the mistake of taking my bike on the subway up to 125th Street
and riding the rest of the way. Lesson learned. Do not take your bike
on the subway during the onset of rush hour! It's a huge pain in the ass,
everyone on the train will hate you, and you probably won't make it to your
destination any faster than you could by just riding there.

Anyway, by the time I got to the Melrose neighborhood, the Ghetto 4 Life
piece had already been prominently side-busted and a security guard (really
just a very big guy with a don't-fuck-with-me attitude) was stationed next
to the wall. A news reporter was on the scene interviewing bystanders and
a steady trickle of locals and fans came and went. It was hard to tell what
people made of the piece.

Opinions were divided. Clearly context matters, and in this instance a
different choice of location (say, Williamsburg) might have salvaged what,
in the Bronx, was at best an ambiguous message. Not even Bronx Borough

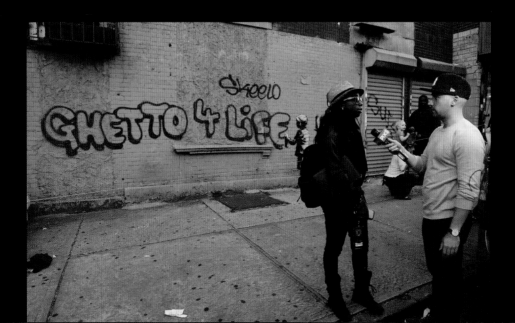

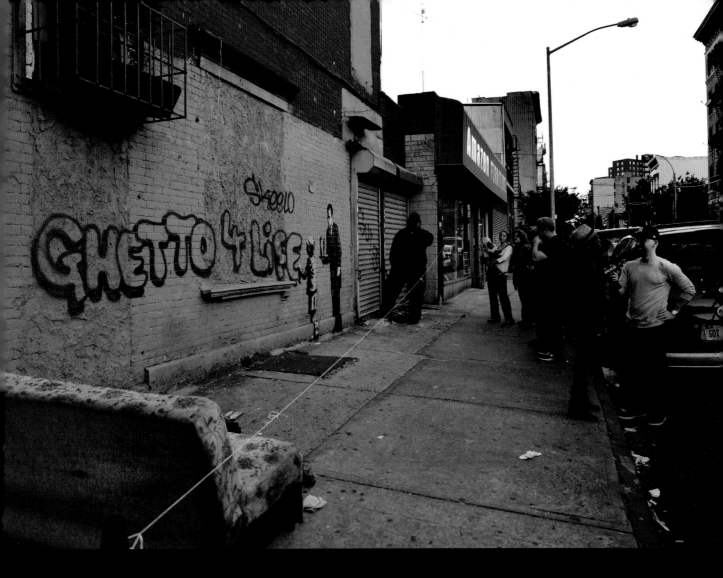

President Ruben Diaz's public disavowal of his support of Banksy following his elation about the Ronald McDonald installation, a flip flop if ever there was one, was able to make light of the situation. Personally, I thought the stencil portion of the piece was executed to perfection. So, you know, just cut that bit out and leave the rest.

* * *

I rode my bike all the way back home after dark, down the long, narrow chute littered with cabs and subway tunnel construction equipment that is Second Avenue, focused entirely on the flow of traffic, racing up and down the hills of Spanish Harlem and Turtle Bay to stay ahead of cars rather than be cut off, high on my speed and my awareness of movement, lights, signs, and faces on the sidewalk. I could die at an instant, but knew for certain that I wouldn't — there was so much still left to do once this wild goose chase was over.

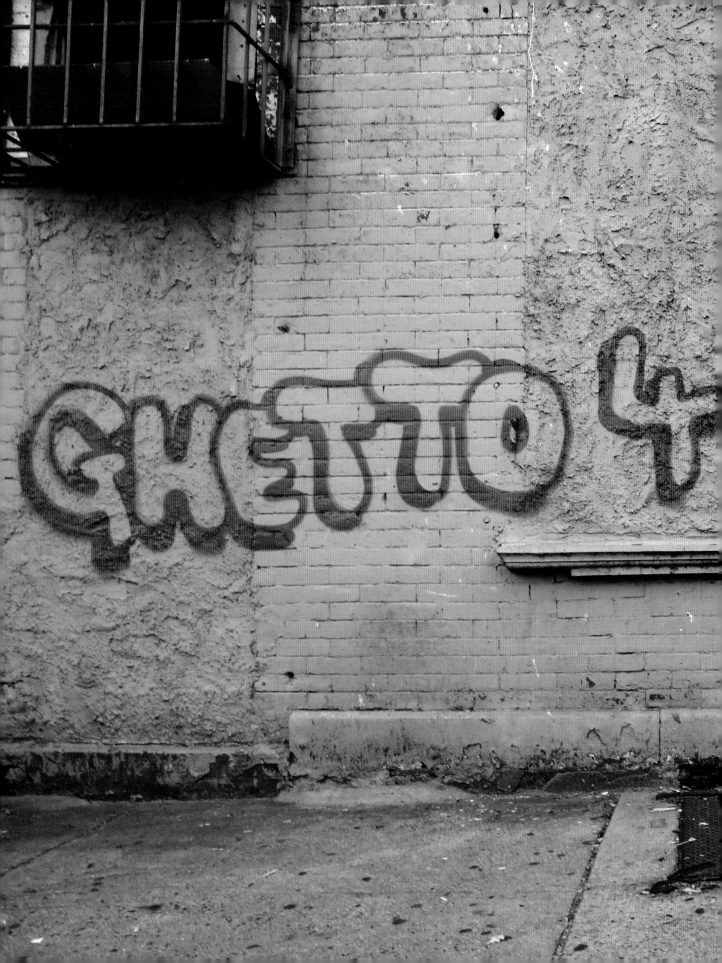

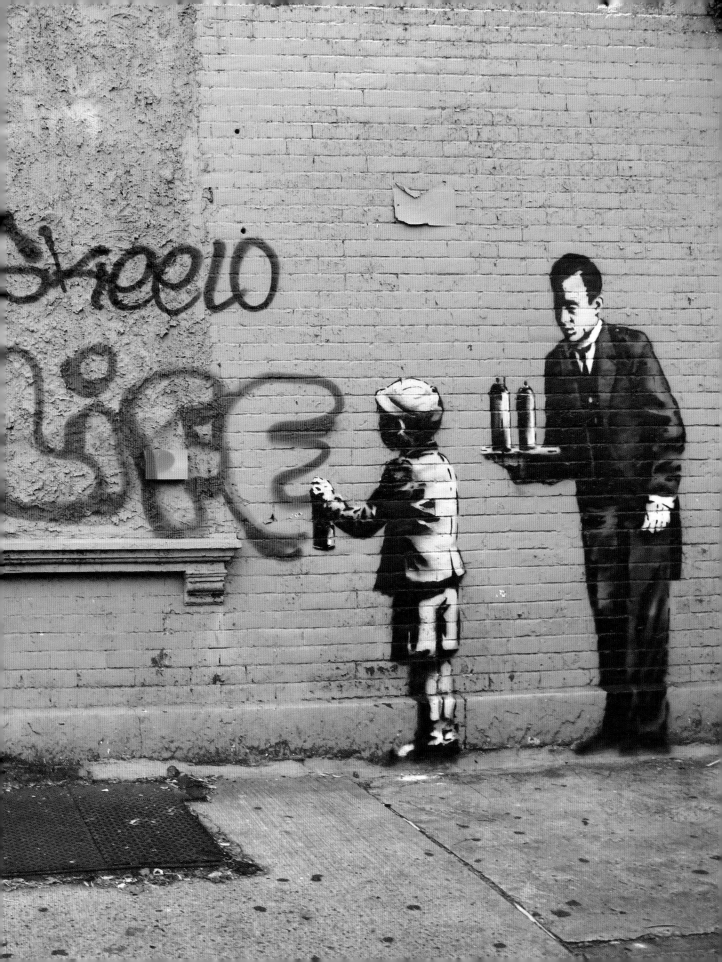

OCTOBER 22: WILLETS POINT

Judging by the initial photo on Banksy's Instagram feed, the Sphinx sculpture could have been anywhere in the city. I was already bracing myself for a trip to Staten Island when someone figured out that it had been planted in Queens. Willets Point, a.k.a. the Iron Triangle, was a pothole riddled warren of auto-body shops, few of which actually appeared on Google Maps, because the rest were not officially designated as buildings. The entire area was slated to become a shopping mall and while some property owners sat tight, many had already begun to move out ahead of the Triangle's inevitable transformation from a great place to make a body disappear to a great place for drunk Mets fans to wander into on game day.

It was an inspired choice of location for the Sphinx sculpture. But was this a benevolent or a malevolent Sphinx? Does the sculpture's presence signify its role as a protector of dead kings, as in ancient Egypt, or as a riddler, ready to devour those who cannot correctly answer its question, as in Greek mythology?

You've heard the story. The Sphinx is the guardian of the city of Thebes and poses all travellers seeking passage the same riddle: "What speaks with one voice, but has first four legs, then two, and then three?" Oedipus, an arrogant trust fund kid and proto-hipster, correctly answers "Man!" and the Sphinx, out of frustration with his misogyny and for lack of a plan B, devours herself. Was that what we were looking at here?

While I still pondered this very, very important question, a local hustler had already made his move and declared the Sphinx his, nevermind its presence on public land, and prepared for its removal. I seem to recall that a few of the bricks that had been piled around the bottom of the sculpture changed hands for something like $50-100. A phenomenal bargain, by New York real estate standards.

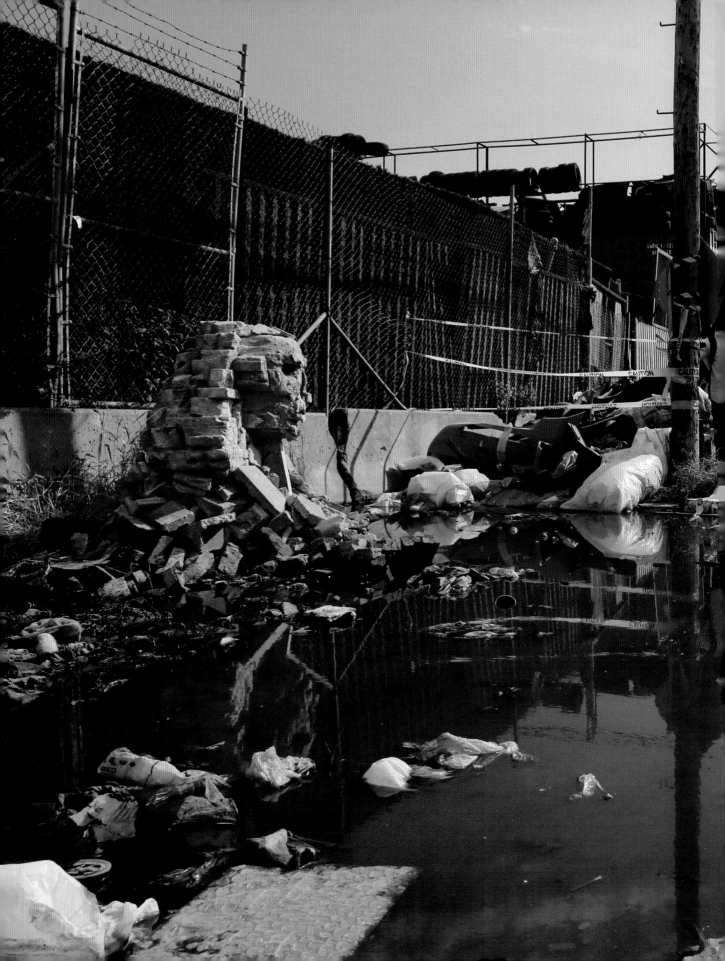

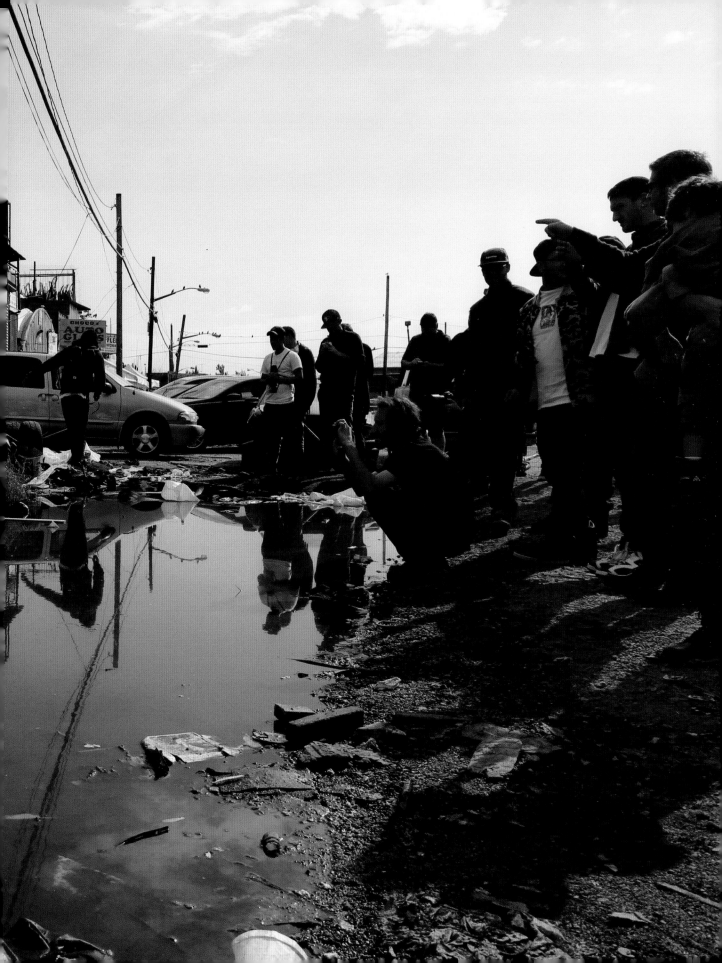

"Today's art
has been
cancelled
due to police
activity."

OCTOBER 23: THE INTERNETS

Your guess is as good as mine.

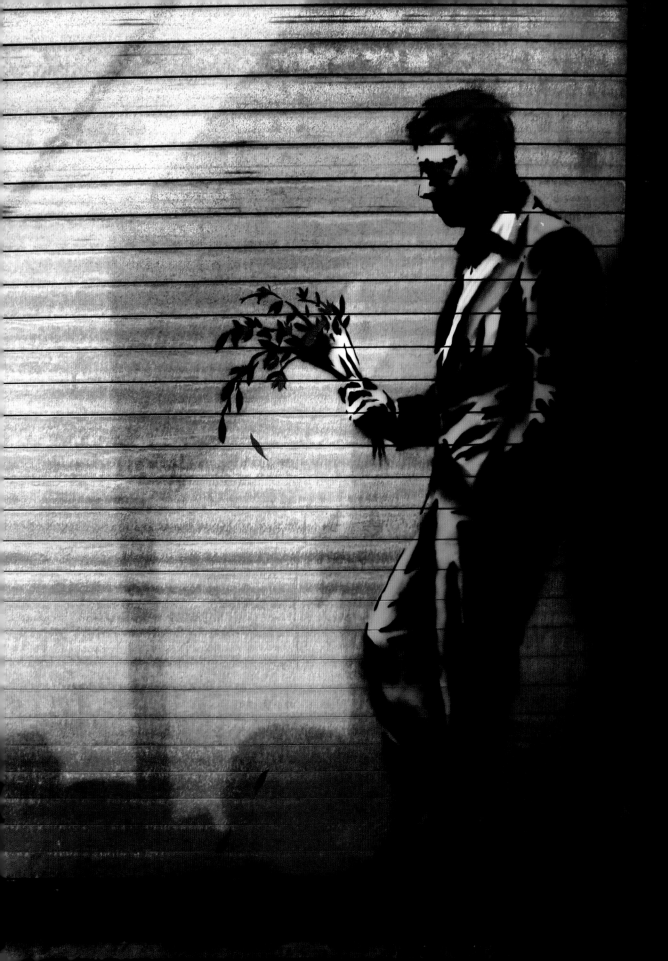

OCTOBER 24: HELL'S KITCHEN

Today's piece begged the question: Of all people in New York to make accidentally rich by leaving a piece of very valuable art on their property, did it really have to be Larry Flynt? Larry Flynt treats objects like women, man — as espoused by the loving care with which the stencil of the guy stood up at the club was cut out of the metal shutter on which it had been painted. Of course, in real life, if you are meeting your date at the Hustler club, you're kinda asking for heartache. But who am I to judge.

What is less known about this piece is that, subsequent to its removal from the scene of its romantic defeat, our lovelorn stencil started an indie rock band and, by reviving a melancholic, self-defeating, but strangely uplifting sound first made popular in the nineties, went on to headline a string of sold-out performances at Barclays Center before commencing a short, but intense affair with James Franco's Japanese love pillow. Fact.

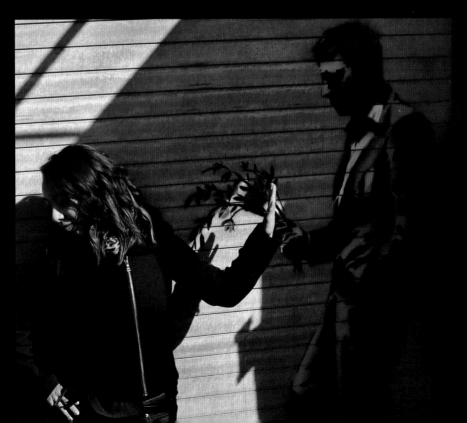

The Grim Reaper auto scooter was actually not the first art installation at the corner of Houston and Elizabeth. At some point a year or two ago, a coffin was propped up in the center of the fenced-in cage that had for many years housed a one-man flea market called Billy's Antiques. The memory of the death of yet another local New York landmark made the carnival-like atmosphere the auto scooter created all the more appropriate, like dancing at a funeral. And of course, Halloween was just around the corner.

The most memorable aspect of the audio commentary that accompanied this installation was that it quoted a passage from *Invictus*, by William Ernest Henley, a favorite of fans of Victorian poetry and screenwriters alike:

> *"Beyond this place of wrath and tears*
> *Looms but the Horror of the shade,*
> *And yet the menace of the years*
> *finds and shall find me unafraid.*
>
> *It matters not how strait the gate,*
> *How charged with punishment the scroll,*
> *I am the master of my fate:*
> *I am the captain of my soul."*

For the next six nights, this particular corner would attract unprecedented crowds and frequently serve as a late night hang-out for the Mobile Waterfall and Sirens of the Lambs trucks. I captained my bike to the neighborhood once or twice during those nights and took photos. It was kinda fun, but whatever. Is this over yet?

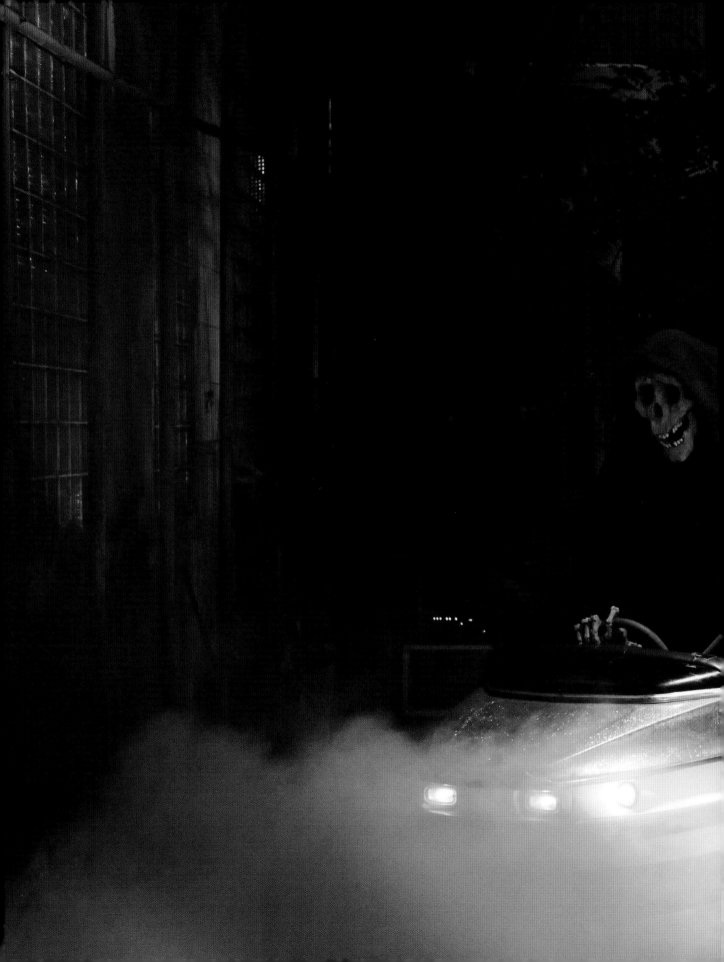

OCTOBER 26: SUNSET PARK

If only this month would never end!

I'd just finished shooting the Assholes truck when I got a message from a Flickr acquaintance from the UK congratulating me on making banksyny.com. I checked the site, and indeed, there was the photo of the Grim Reaper I had posted online the night before, and underneath it, in a glorious 5 point, light grey font, my photo credit! Hooray!

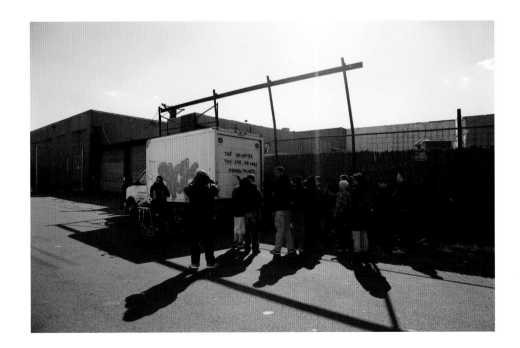

OCTOBER 27: GREENPOINT

Dear Banksy. There was a reason the New York Times refused to print your editorial (if you ever meant for them to publish it in the first place). It was a very poorly conceived and executed piece of writing. Its timing was off by many years, its architectural critique was unrelatable to most folks (though not without merit), and its tone was jarring and cringe-worthy. It sucked.

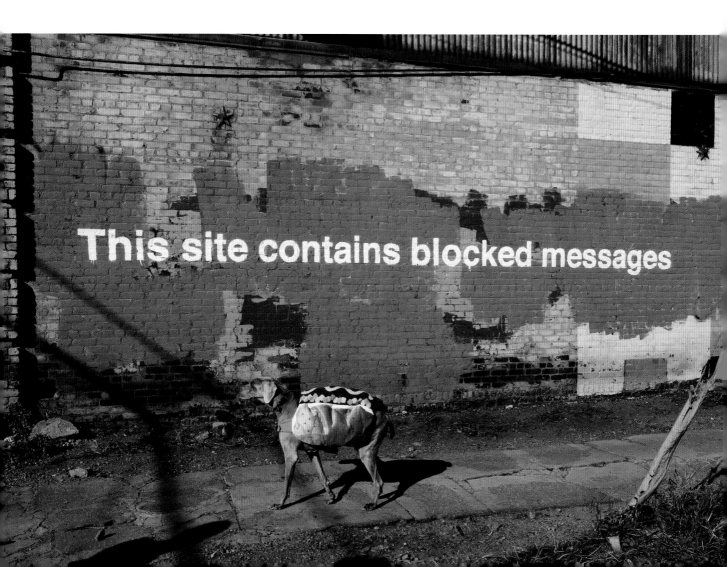

You wrote that "nobody comes to New York to bathe in your well-mannered common sense. We're here for the spirit and audacity." I'd like to believe that, despite the mundane challenges of everyday life once you actually live here, this is true.

But spirit and audacity don't come from buildings, they come from people, as I think you know very well, and our confidence as New Yorkers, nurtured and passed down for generations to natives and newcomers alike, cannot be tickled by one mediocre concrete-and-glass blob. We already knew that we are better than that.

So we keep chasing our dreams, thinking big, painting, building, remembering and occasionaly innovating. Sometimes we make bad decisions, and at other times we probably take ourselves too seriously. Sometimes we like to oversell our vices and undersell our virtues, and vice versa. And, yes, sometimes we just go on and on and get all tangled up in meaningless word play and make shambles of metaphors, like a scultpor throwing clay at a wet wall.

Wait, what?

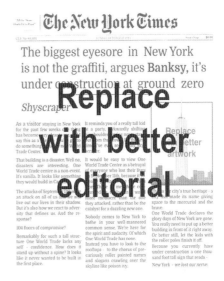

Unfortunately, what got lost in the discussion following the non-publication of the editorial was that the Blocked Messages piece in Greenpoint was quite nicely executed. While its overt message appeared to refer to the rejected op-ed, which is kind of a non-starter in the age of the internet (since the text got circulated anyway), the sub-text was graffiti 101: The message was painted on a wall in Greenpoint that bears many layers of paint from previous graffiti-buffing efforts. These are the blocked messages that constantly have to fight to be heard. It was fitting that, unlike the pieces that got preserved only to be auctioned off, this one was simply painted over.

OCTOBER 28: CONEY ISLAND

We had a lot of good luck with the weather in October, and today was no exception. The ride to Coney Island was a straight shot and I didn't have to look very long until I found the stencil of the robot with a small crowd gathered in front of it, just a few blocks from a still-intact, giant Os Gemeos mural.

Once again I heard of a sighting of one or two men with a van around six in the morning. That's 11am GMT, so no big deal, really. Every Euro tourist knows the drill. You get into town, aching to explore the city and wake up jet-lagged at five in the morning only to find that nothing's open yet. What do you do? You go to Coney Island, paint a quick piece, and hopefully by the time you are done the Midtown bagel carts will be serving breakfast and the museums will be open. While we were stuck near the beach, Banksy was probably already studying the works of the modern masters at MoMA. Or perhaps he was tanning at the beach. I know, I know, I'm kidding. Everyone knows that Brits can't get a tan. (And neither can I, for the record.)

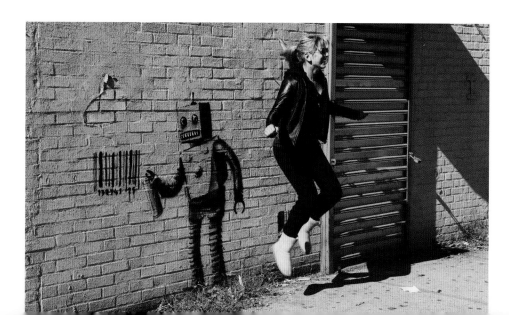

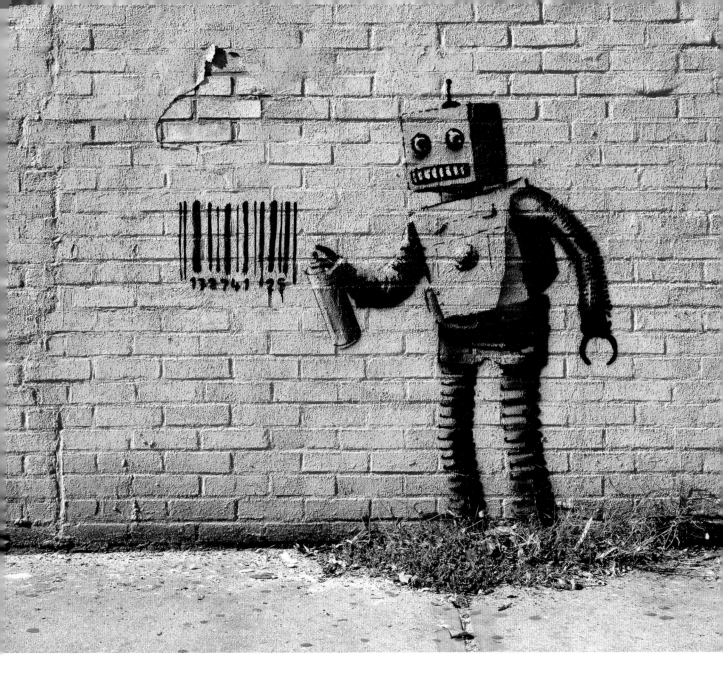

At this point I'd also like to give a shout out to all of the press photographers who participated in the daily schlep, some of whom I slowly started to recognize. They probably hustled about as hard as anyone to get a piece of the action, and some of them definitely looked as under-employed as anyone I know, racing to the scene by bike or on foot and waiting their turn to get shots. But while I could hop on my bike and ride off once I got bored, they were condemned to sticking around, always weary not to miss out on newsworthy developments. On the other hand, they had jobs, and much fancier equipment, so they must have been doing something right.

OCTOBER 29: HOUSING WORKS

Banksy had been very clear that his residency was not about selling art, as much as his reputation would grow from the prolonged exposure. With his donation of an altered painting to Housing Works, a very worthy charity that benefits homeless people and people with HIV/ AIDS, he made good on that assertion. The painting was a landscape featuring what appeared to be a Nazi soldier, a monster without a name. Its title, "The banality of the banality of evil," can be read as a double negative or perhaps as a criticism of the casualness with which we have come to think of true evil in media and entertainment, until it touches us personally.

(There was as a small hiccup in the auction when the high bidder withdrew his/her bid, but ultimately the painting was sold for a price in the mid-six figures, as reported by the New York Times.)

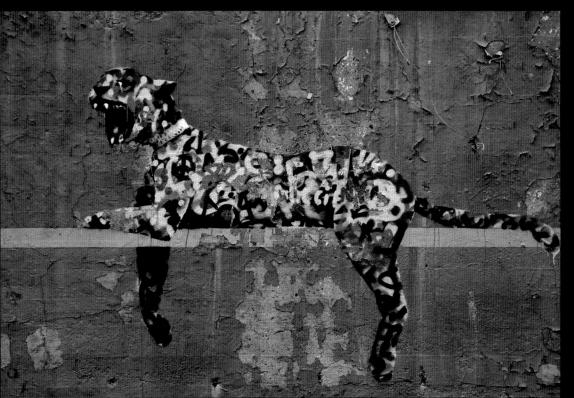

The location of the leopard wasn't revealed until the early evening of the 30th. This piece appeared to have been created by spraying layers of tags inside a stencil cut-out to create a life-like camouflage perfectly suited to the urban jungle. The idea was not new — Banksy had created a similar piece for the Cans Festival in London in 2008.

I had a very important soccer match to play that night — our team was trying to turn around a persistent losing streak, and tonight had to be the night when we would finally get an opponent to crack. I did the math and realized that I wasn't going to be able to make it to Yankee stadium and back to Brooklyn in time for the match. In all likelihood the leopard would be trashed by morning, but fuck it. A man has to pick his battles.

We lost, again. But it was one of those uplifting, narrow losses, and so we stayed up late to celebrate.

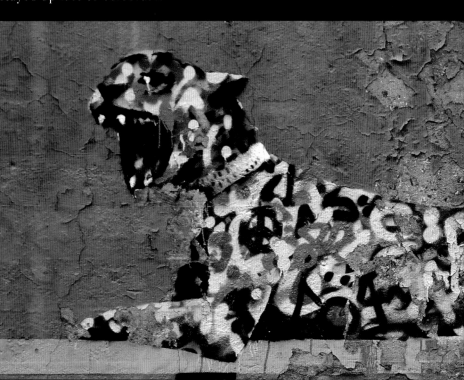

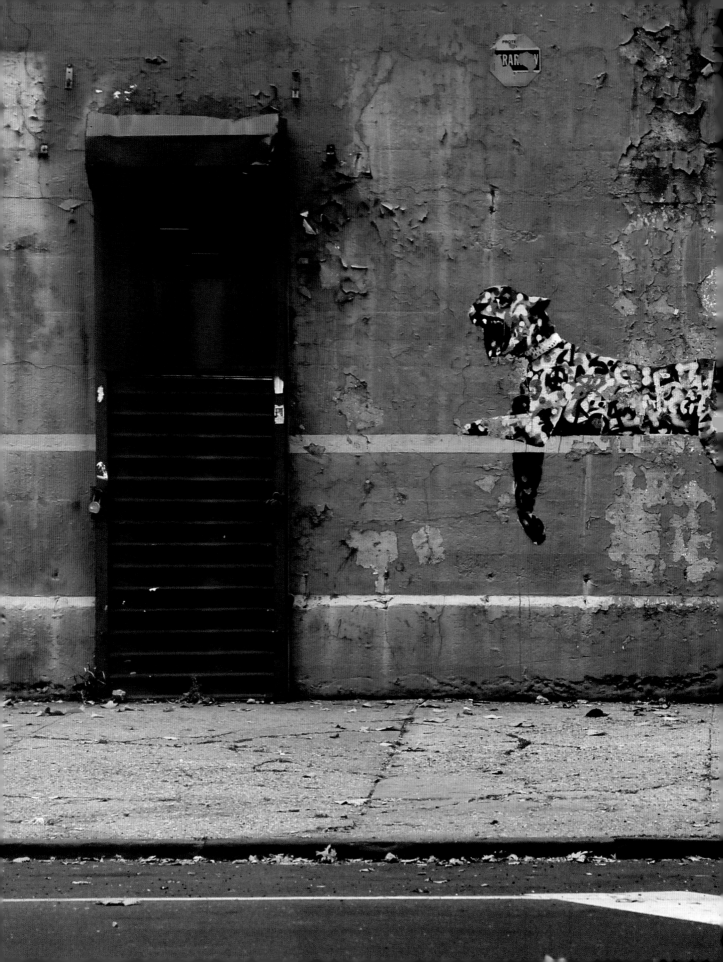

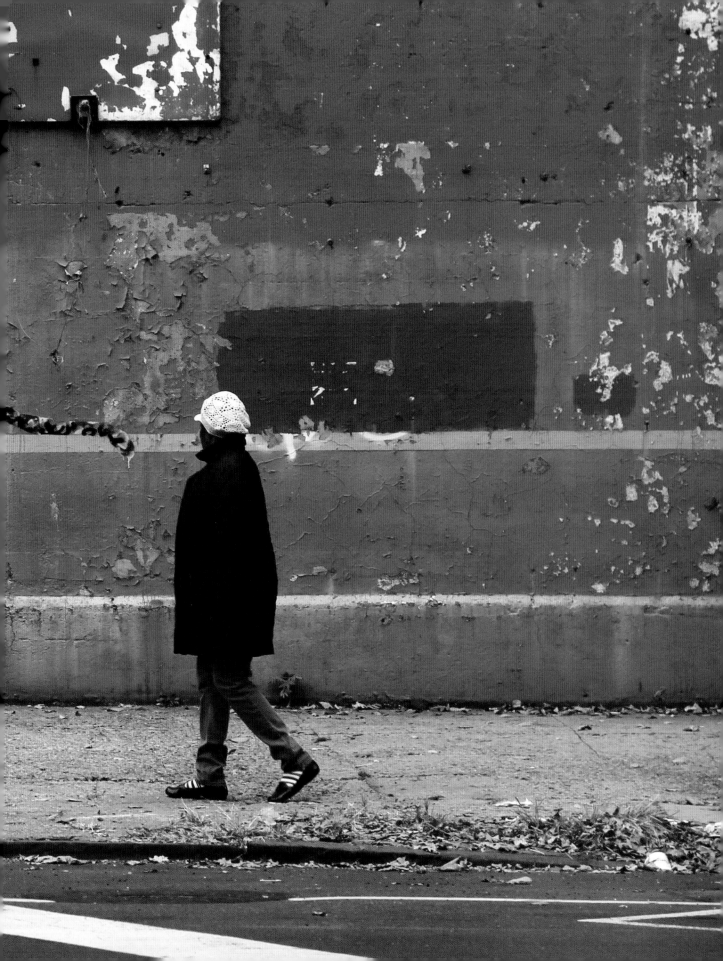

OCTOBER 31: MASPETH

This was it. The grand finale was upon us. I had convinced myself that Banksy would pull out all the stops for this one. It had to be a float in the Halloween parade. Sure, the Reaper was already sort of a Halloween-themed installation. But Banksy would go out with a bang, wouldn't he?

A friend suggested that the most radical thing Banksy could have done to end his New York residency would be to allow himself to get arrested and exposed. He could have turned an occupational hazard into a once-in-a-lifetime piece of performance art. Would that have ended his career or propelled his public persona to ever-greater fame? It turned out that neither of us were correct in our guesses.

* * *

I raced to Yankee Stadium in the morning and to my surprise the leopard was still there, and only a few other folks had made the track to the west side of the stadium to see it. I was happy with my shots, but as it turned out my timing was totally off today.

Just as I arrived back in my neighborhood in Brooklyn, the photo of the final piece, the bubble letter balloon, was posted on Instagram. I knew exactly where it was, a fantastic location right off the Queens Midtown Expressway with prominent Adek and Lewy fill-ins that had been running for years. It took me less than half an hour to get there, but it was too late. The balloon was on the ground, half-deflated, there were cops all over the place and spectators crowded the sidewalks, including most of the fans and press photographers I'd seen almost daily this month. Three guys were in custody for trespassing. Two of them had cut down the bubble letters, presumably in hopes of a quick windfall.

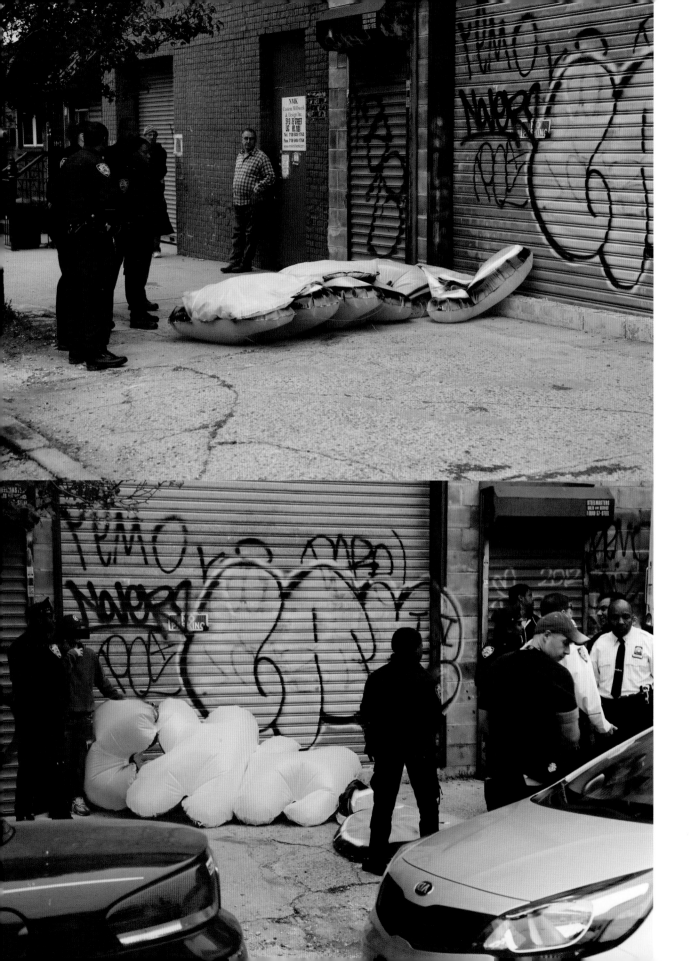

"Don't worry, you'll be out tomorrow," a sympathetic onlooker shouted at them. "Fuck Banksy!"

This guy was clearly over Banksy. He probably only trekked all the way to the ass of Queens to meet girls. I suppose that is reasonable. He had a point though. The kids were going to be out tomorrow, whereas the bubble letters would be in police custody indefinitely.

And it was just as well. Because tomorrow, I could get back to what really mattered: Shooting graffiti, making zines and looking for a new job. Barry McGee, aka Twist, had been in the city not long ago. Revs tags had been spotted downtown. JA had left crisp marker tags and outlines right on my route to the Manhattan bridge. A number of very reputable older cats were coming out of retirement and a new crop of young writers was killing it on the streets.

High above us, in Chelsea and on the Upper East Side, the Art World was wagging its collective finger at Banksy, if it paid any more attention at all. Somewhere in New York, extremely talented artists were literally starving, or moving out of town. Some chose to take their work to the streets, out of passion, desperation, a need for attention, or all three. We were left with the difficult task of figuring out what all this meant in the big scheme of things, and perhaps the answer was of Seinfeldian simplicity: Nothing.

Banksy's response in the last audio commentary was unusually clear and urgent: "[Outside] is where art should live, amongst us. And rather than street art being a fad, maybe it's the last thousand years of art history that are the blip, when art came inside, in service of the church and institutions. But art's rightful place is on the cave walls of our communities where it can act as a public service, provoke debate, voice concerns, forge identities."

Put differently, we have to keep doing the hard work of asking what is art, not because there is a definite answer, but because the process of asking what is art, and what is work, and how do we know that, and who do we think we are anyway is going to teach us more about ourselves, our culture and the people around us. As a famous philosopher once said: "I may not know where I'm going with this, but I know we'll get there."

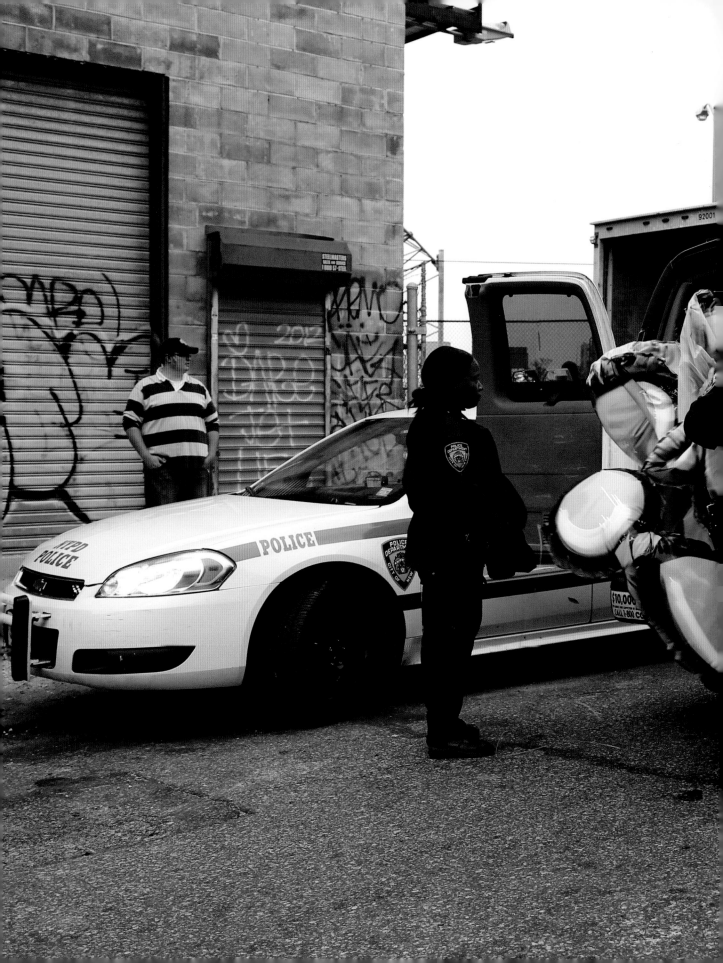

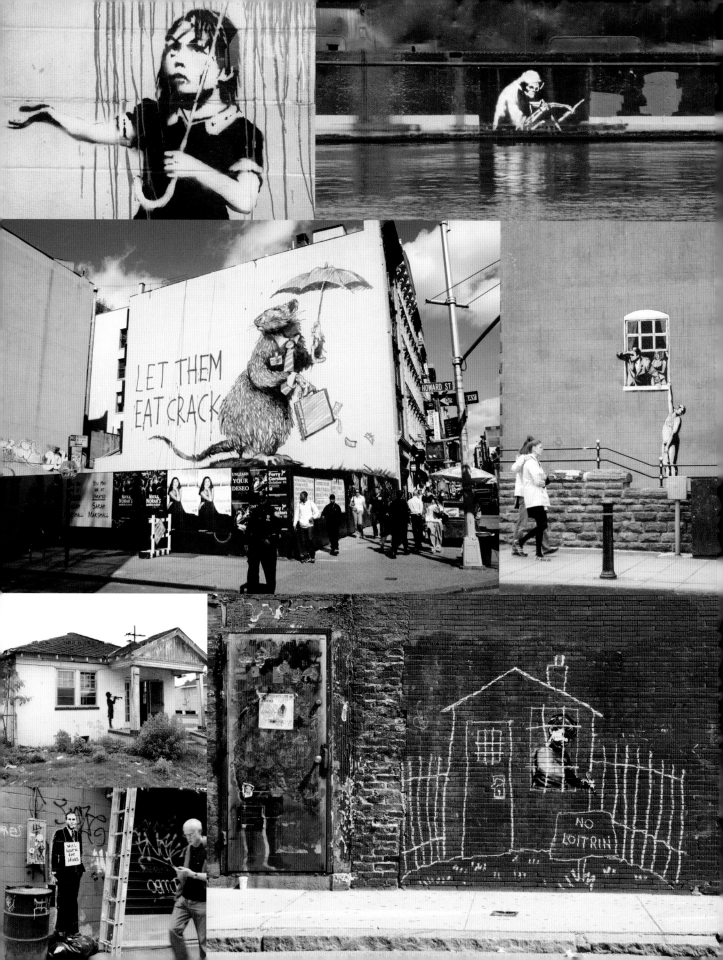

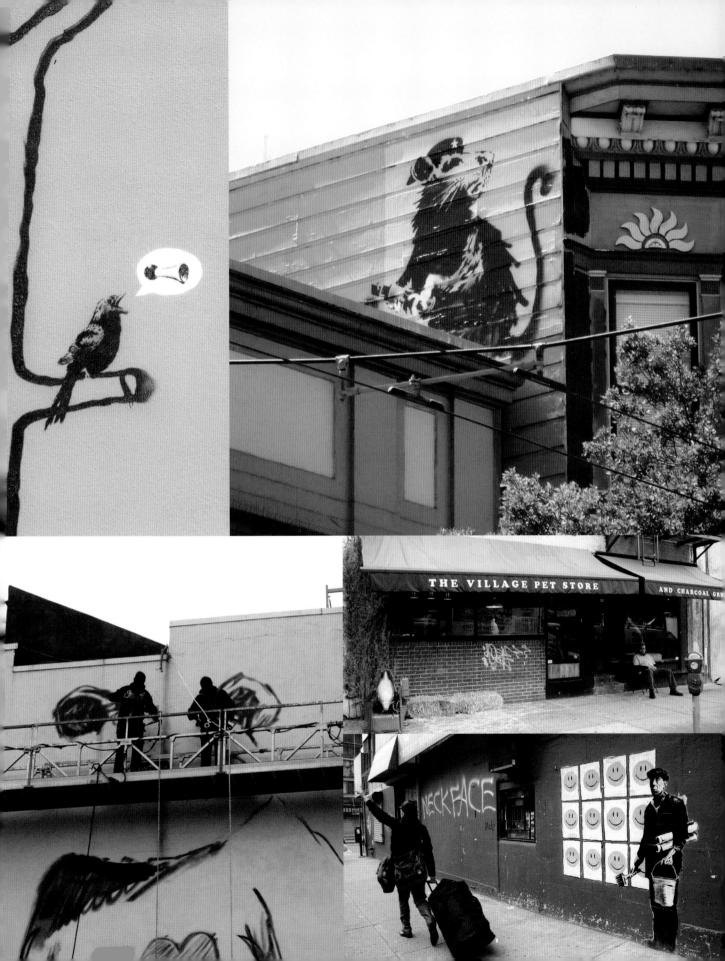

All photos and illustrations by Ray Mock, except the following: page 7-14 by Jaime Rojo (IG @bkstreetart, www.brooklynstreetart.com), page 26 (bottom) by Smart Crew, page 29 by Luna Park (IG @lunapark), page 33/34 by Luna Park, page 40 by Erika Sequeira (IG @sakiwaki), page 53 by Erika Sequeira, page 73 by Derek Storm and page 117 by Hrag Vartanian (IG @hragv).

Sources:

Acker, Christian P. *Flip the Script*. Berkeley: Gingko Press. 2013.
"Banksy-Altered Painting Brings $615,000 at Auction." Melena Ryzik. *The New York Times*. October 31, 2013. www.nytimes.com
"Banksy Announces a Monthlong Show on the Streets of New York." Melena Ryzik. *The New York Times*. October 1, 2013. www.nytimes.com
Henley, William Ernest. *Book of Verses*. England. 1888.
"Jerry Saltz Ranks Banksy's New York City (So-Called) Artistic Works." Jerry Saltz. *Vulture*. October 31, 2013. www.vulture.com
"Massacre Caught on Tape: US Military Confirms Authenticity of Their Own Chilling Video Showing Killing of Journalists." No byline. *Democracy now*. April 6, 2010. www.democracynow.org
Steinbeck, John. *The Grapes of Wrath*. New York: The Viking Press. 1939.
"Village Voice Exclusive: An Interview With Banksy, Street Art Cult Hero, International Man of Mystery." Keegan Hamilton. *The Village Voice*. October 9, 2013. www.villagevoice.com

Audio commentary transcribed by the author from copies of the audio files shared on YouTube.

Thanks:

Special thanks to all contributors. This book would not be possible without your help.

Also thanks to all of the folks who came along for the ride and kept things positive day in and day out. Till we meet again.

Much appreciation and gratitude to Seine Kim, Michael Fales and Lee Root as well as everyone else who shared feedback and encouragement throughout the making of this book.

Lastly, thanks to Banksy for giving us an excuse to roam around New York and for providing free entertainment and exercise. Clearly we needed both.

Visit www.carnagenyc.com or follow us on Instagram at @carnagenyc for updates on new releases and a steady onslought of the best graffiti in New York and around the world.

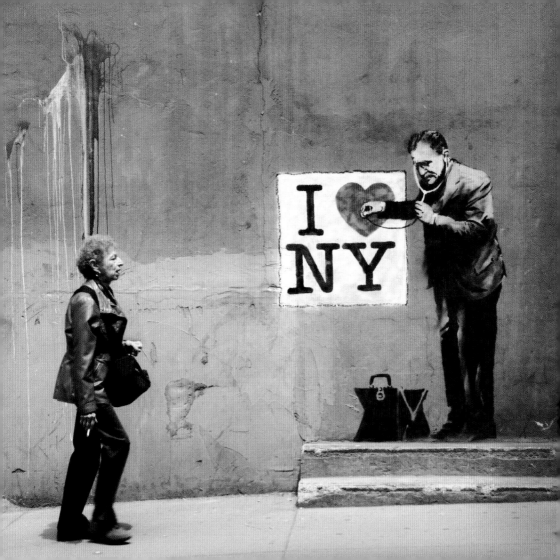